The Third Dimension

Sculpture
of the
New York School

Lisa Phillips

Whitney Museum of American Art, New York

Dates of the exhibition:

Whitney Museum of American Art
New York, New York
December 6, 1984–March 3, 1985

Fort Worth Art Museum
Fort Worth, Texas
May 12–July 21, 1985

Cleveland Museum of Art
Cleveland, Ohio
August 21–October 17, 1985

Newport Harbor Art Museum
Newport Beach, California
November 7, 1985–January 5, 1986

This exhibition was organized by the
Whitney Museum of American Art with
a grant from the National Committee of
the Whitney Museum of American Art.

Library of Congress Cataloging in
Publication Data

Phillips, Lisa.
 The third dimension.

 Catalog of an exhibition to be held at the
Whitney Museum of American Art, New
York, and at 3 other museums from Dec. 6,
1984–Jan. 5, 1986.
 Bibliography: p.
 1. Abstract expressionism—United
States—Exhibitions. 2. Sculpture,
American—Exhibitions. 3. Sculpture,
Modern—20th century—United States—
Exhibitions. I. Whitney Museum of
American Art. II. Title.
NB212.5.A27P48 1984 730'.973'074013
84–21962
ISBN 0-87427-002-2

Copyright © 1984
Whitney Museum of American Art
945 Madison Avenue
New York, New York 10021

National Committee of the Whitney Museum of American Art

Contents

Acknowledgments

In the course of preparing this exhibition, I have had the enormous good fortune and pleasure of working directly with many of the artists. Without the benefit of their involvement, the development of a more complete, revised picture of the era could not have been achieved. For sharing recollections, works of art, and personal papers, my very special thanks are extended to Peter Agostini, Louise Bourgeois, Herbert Ferber, David Hare, Ibram Lassaw, Michael Lekakis, Seymour Lipton, Louise Nevelson, Isamu Noguchi, and George Sugarman.

I am especially grateful to the other individual and institutional lenders who so generously made works available for the exhibition and its subsequent tour. My appreciation also goes to those who assisted in locating works and securing loans: Dr. Joyce Lowensen, Gary Reynolds, Virginia Zabriskie, Beth Urdang, Jim Reinisch, Jerry Gorovoy, David McKee, Kendall Lutkins, Sara Jane Roszak, and Lillian Kiesler. Several others have also contributed valuable expertise and counsel: Richard Bellamy, Irving Sandler, Joan Pachner, Wade Saunders, Steve Miller, Phyllis Tuchman, Philip Pavia, John Newman, and Jane Smith.

This exhibition is an elaboration of "Sculpture in the Age of Painting," presented at the Museum's Downtown Branch in 1979. Though the exhibition was a collaborative effort, Len Klekner deserves credit for its conception and principal leadership.

Without the support of Tom Armstrong, Director of the Whitney Museum, the exhibition would not have taken place. Its planning and development required the effort and energy of many members of the Museum staff, to whom I am very grateful.

I was especially fortunate to find an exceptionally talented assistant in Nancy Princenthal, who also took on the enormous task of writing the biographic and bibliographic entries and compiling the chronology. I am also greatly indebted to Brooke Kamin, who attended to the many details of the exhibition and catalogue with precision and intelligence.

Finally, I must thank architect Christian Hubert and his associate, John Nambu, for the installation design. Through their sensitive response to the complex requirements of the work, our perception of the period is significantly enhanced.

L.P.

Foreword

The achievements of American sculptors in the 1940s and 1950s have generally been overshadowed by those of the Abstract Expressionist painters. The major innovations in postwar sculpture have received little critical or scholarly attention.

Sculpture has traditionally represented an important aspect of the programs of the Whitney Museum of American Art since its founding in 1930 by Gertrude Vanderbilt Whitney, herself a sculptor. This exhibition continues that tradition, providing an opportunity to explore the inventive forms of expression which emerged in American sculpture after World War II.

During the period covered by this exhibition public and private patronage of American sculpture was represented by a very small group, the most significant of whom for this institution were Howard and Jean Lipman. The Lipmans' loyalty to American art and to the Whitney Museum, encouraged by Jack Baur, who began his association with the Museum in 1952 and was Director from 1968 to 1974, ultimately made the Museum synonymous with twentieth-century American sculpture. The works they acquired, many of which are represented here, and even more important their spirit and respect for the artists, constitute a vital part of the history of the period and of the Museum.

The Whitney Museum has maintained a long and close association with many of the artists whose works are included in this exhibition, a number of whom—Alexander Calder, Mark di Suvero, Herbert Ferber, Michael Lekakis, Louise Nevelson, Isamu Noguchi, Theodore Roszak, and David Smith—have been the subject of one-artist exhibitions. All the artists in the show are represented by at least one work in the Permanent Collection.

We are extremely grateful to the National Committee of the Whitney Museum, which is sponsoring the exhibition at the Whitney Museum and subsequently at the Fort Worth Art Museum, the Cleveland Museum of Art, and the Newport Harbor Art Museum. The National Committee has played a major role in assisting the Museum to extend its programs to a national audience, thereby increasing public awareness and understanding of American art.

The exhibition has been organized by Lisa Phillips, Head, Branch Museums, and Associate Curator, who first became associated with the Whitney Museum in 1976 as a Helena Rubinstein Fellow in the Independent Study Program. This exhibition is an extension of her initial research for the exhibition "Sculpture in the Age of Painting," which she co-organized in 1979 when she was Manager of the Whitney Museum of American Art, Downtown Branch.

It is always an honor to extend our thanks to the lenders of an exhibition for their cooperation throughout the project. In this particular case, these lenders represent connoisseurs of American art who recognized quality in works of art without regard to established taste and the burden of fashion. They are sharing and participating in a re-evaluation and we are the fortunate recipients of their generosity.

TOM ARMSTRONG
Director

The Third Dimension

Sculpture of the New York School

"Let us consider the sculptors first, since in aesthetic discussions they are usually mentioned last and grudgingly, sculpture being a difficult art, not easily loved by the public nor even by most connoisseurs. Yet one of our period's distinctions is that it has produced so many sculptors of real consequence. . . . In America there are signs that sculpture is gaining ground as a medium in which younger artists prefer to work" (James Thrall Soby, 1947).[1]

"What is to be pointed out is that painting's place as the supreme visual art is now threatened whether it is in decline or not. And I want also to call attention to sculpture, an art that has been in relative desuetude for several centuries but which has lately undergone a transformation that seems to endow it with a greater range of expression for modern sensibility than painting now has" (Clement Greenberg, 1949).[2]

In the years following World War II, there was a sense of boundless possibility for American art. With the upheaval in Europe, it was incumbent upon the United States to assume the guardianship of culture, and American artists set a new course for themselves, in keeping with the country's drastically revised self-image. These conditions precipitated a critical phase of self-discovery and growing stylistic certainty for American painters and sculptors which culminated in the celebrated rise of a significant American art form: Abstract Expressionism.[3]

The new American sculpture, to which both Soby and Greenberg referred, coincided with the development of Abstract Expressionist painting—what has come to be known as the New York School. As Greenberg perceived, the new sculpture presented itself with great vigor and potential. He went on to speculate that "the number of promising young sculptors far exceeds the number of painters who will figure eventually in the history of art of our times," citing David Smith, Theodore Roszak, David Hare, Herbert Ferber, Seymour Lipton, Richard Lippold, Peter Grippe, Burgoyne Diller, Adaline Kent, Ibram Lassaw, and Isamu Noguchi as among those demonstrating exceptional talent and inventiveness.[4]

But in the three decades since Greenberg wrote, these sculptors' names have, with the notable exception of David Smith, been dwarfed by those of painters—Jackson Pollock, Willem de Kooning, and Franz Kline. As Abstract Expressionist painting reached its "triumphant" apogee, the considerable achievement of postwar sculpture was eclipsed, reduced to "the thing you back into when you look at a painting."[5]

While the term "Abstract Expressionism" gained acceptance in the late 1940s as a way to identify the developing contemporary vanguard movement in New York, it quickly came to denote a painting style. Although there was considerable dissent among painters about the validity of the term and its application to their work (de Kooning: "It is disastrous to name ourselves"[6]), it was nevertheless understood to relate to the history and problems of painting: namely, the crisis of the easel picture; the necessary redefinition of scale, color, and surface; the purging of illusionism and narrative content; and the establishment of the canvas as an "arena in which to act."

The history of the New York School, codified by Harold Rosenberg, Dore Ashton, Irving Sandler, Thomas B. Hess, and Barbara Rose, among others, has thus been written primarily from the perspective of painting.[7] Even Greenberg, easily the most influential critic of the period, repudiated his earlier claims for sculpture in a growing obsession with two-dimensionality and the picture plane, relegating most of the sculpture made during that time to a marginal position.[8]

As the interest and enthusiasm for Abstract Expressionist painting grew, the sculptors found themselves outside the rhetoric. They did share a community of purpose with the painters during these years—the desire to forge an "authentic" aesthetic distinct from European prototypes through the exploration of a mythic and metaphysical dimension. However, a precise stylistic counterpart for sculpture could not be established: the obdurate materials of sculpture precluded the totally fluid, spontaneous movement that paint on canvas allowed.

The physical properties of sculpture were also obstacles to the marketing and increasing commodification of art. Unwieldy, heavy, and space displacing—especially as it increased in scale during the fifties—sculpture was unaccommodating by most collectors' standards. Difficult to sell, and difficult to classify in terms of the prevailing aesthetic, sculpture of the New York School has remained outside the mainstream—an art historical "loose end."

The sculptors themselves exacerbated the problem of classification by disavowing a common style and rhetoric. Their pursuit of idiosyncratic and stylistically varied forms further worked against their assimilation into the mainstream. As Wayne Andersen noted in 1965: "The principal cause underlying the ways sculpture and painting emerged from the forties was that there were quite definite groupings of the painters but not of sculptors; groupings of the latter have only begun in recent years."[9] This observation confirmed Herbert Read's earlier position that "What is distinctive about the post-war situation, particularly in sculpture, is a determination to belong to no movement, an artistic 'free thinking.'"[10] In Harold Rosenberg's estimation, the reaction against a collective manifestation was "stiffened by the individualism that has become the militant creed of the post-war west."[11]

This individualism has been reinforced by the critical literature, which approaches sculpture of the period principally in terms of a few exceptional talents, disconnected from major stylistic trends (Isamu Noguchi, Louise Nevelson, Alexander Calder). When sculptors are grouped it is often according to technical approaches, such as "constructed sculpture," "direct metal," or "assemblage." The direct-metal sculptors (David Smith, David Hare, Seymour Lipton, Herbert Ferber, Ibram Lassaw) have sometimes been nominally allied with Abstract Expressionism because of the relative immediacy and chance effects afforded by the welding torch. More frequent, though, is the treatment of sculptors who emerged in the late 1950s (John Chamberlain, Mark di Suvero, Peter Agostini) as the first "authentic" Abstract Expressionist sculptors, the gestural process and appearance of their works giving a literal dimension to the implied space of the painters.

It is not the purpose of this exhibition to propose a new cohesive nomenclature for the sculpture of this era, but rather to present the work as an entity independent of painting and subject to its own historical dialectic. During this dramatic phase of

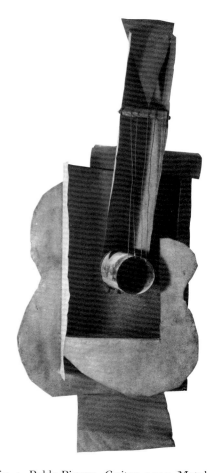

Fig. 1. Pablo Picasso, *Guitar*, 1912. Metal and wire, 30 x 13 x 7½" (76.2 x 33 x 19.1 cm). The Museum of Modern Art, New York; Gift of the artist.

sculptural activity the medium acquired unprecedented flexibility and range. Liberated at last from the stranglehold of monolithic carving, postwar sculptors favored a dynamic aesthetic of raw, open, penetrating forms. They assimilated the lessons of the European avant-garde to produce their own inventive fusion of Cubist-Constructivist techniques with Surrealist and expressionist overtones and continuously extended sculpture beyond its traditional boundaries into the territories of painting, drawing, and architecture.

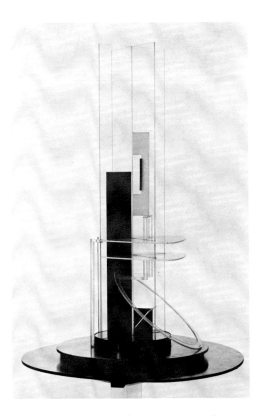

Fig. 2. Naum Gabo, *Column*, c. 1923 (reconstructed in 1937). Perspex, wood, metal, and glass, 40½ x 29 x 29″ (102.9 x 73.7 x 73.7 cm). The Solomon R. Guggenheim Museum, New York.

During the early twentieth century, sculpture's course was radically redirected. At the hands of the Cubists, the medium was delivered from the conditions previously required of it: the imitative representation of the figure, the carving or modeling of mass and volume around a central core, and the exclusive use of stone, wood, clay, plaster, or bronze. These restrictions were instantly rendered obsolete by a single work: Picasso's *Guitar* of 1912 (Fig. 1). A relief construction of sheet metal and wire, this three-dimensional planar counterpart of Cubist painting paved the way for twentieth-century constructed sculpture. With the advent of such radical practices as collage and construction, sculpture could be "built," "assembled," "arranged," or "placed" in any conceivable material. Tin, iron, cloth, concrete, glass, plastic, steel, aluminum, copper, wire, and rubber were soon to enter the sculptor's repertory. Constructivism made use of unorthodox industrial materials, such as advanced technology metals and plastics, to make space visible. The delicate, interlocking, transparent planes of the Constructivists (Fig. 2) finally supplanted the weight, centrality, and immobility that had traditionally characterized sculpture.

Marcel Duchamp's "ready-mades" demanded further mental readjustment: it was no longer necessary for the artist to physically make sculpture—any existing object in the world could be appropriated and presented by the artist as art. The act of naming was all that was required to give an ordinary object special status. Found objects were subsequently incorporated into Surrealist works in disjunctive combinations for poetic and provocative effects. Rejecting rational narrative, the Surrealists turned to primitive cultures and "dreamwork" as a source of psychic charge and adopted the abstract biomorph—an ambiguous organic form with primordial and sexual associations—as their principal metaphor for the unconscious.

The Cubist-Constructivist-Surrealist revolution in sculpture did not reach America until the 1930s. Until then, sculptural production in this country was limited, and abstract works were rarely more than modest, tentative statements. Cultural isolationism and lack of patronage precluded the acceptance of modernism in America. Even the 1913 Armory Show in New York, which introduced the sculpture of Brancusi, Alexander Archipenko, Wilhelm Lehmbruck, Raymond Duchamp-Villon, Picasso, and Elie Nadelman, seemed to have little impact on the style of practicing American sculptors.[12] While a number of artists endeavored

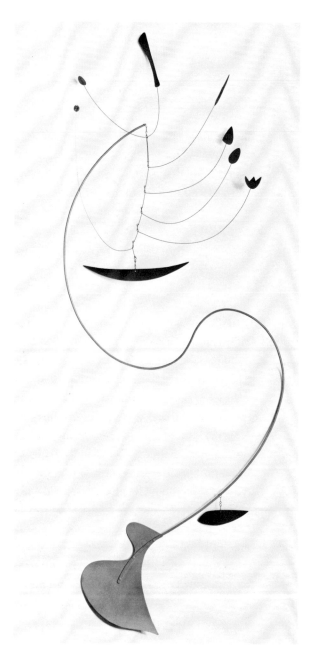

Fig. 3. Alexander Calder, *Mobile with S*, c. 1940.
Painted sheet metal, rod, and wire. 70" (177.8 cm)
high. Collection of Dorothy C. Miller.

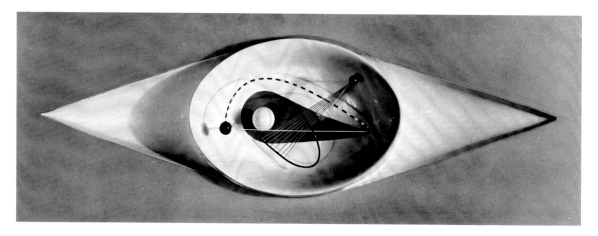

Fig. 4. Theodore Roszak, *Elliptical Arrangement*, 1937. Painted wood and steel, 9⅞ x 23⅞ x 3" (25.1 x
60.6 x 7.6 cm). Sid Deutsch Gallery, New York.

to escape the academic, Beaux-Arts tradition, they did so through the back door of humble subject matter (as in realist genre sculpture) or by returning to a folk tradition, with the simplifying, archaizing mode of direct carving.

Although direct carving was considered the sculptural vanguard in America until the early 1940s, European avant-garde movements began to infiltrate American sculpture during the 1930s. The precocious experiments of a few sculptors —Alexander Calder, Isamu Noguchi, David Smith, Theodore Roszak, and Ibram Lassaw—reveal a coalescence of European influences. Their work laid the foundation for the explosion of abstract sculpture that would follow World War II.

Calder and Noguchi were the first Americans to assimilate the advanced trends of Cubism, Constructivism, and Surrealism. Both sculptors had had sustained contact with the European avant-garde. Calder, who lived in Paris from 1926 to 1933, was encouraged in the direction of abstraction by Duchamp and Miró. His wire constructions of the late 1920s, of which the famed *Circus* is the culmination, were also made at the time Picasso and Julio Gonzalez were creating their first welded, open-form constructions. Calder credited a visit to Mondrian's studio in 1930 as his principal impetus for the development of an abstract idiom, and his early experiments with abstraction reflected the Surrealist and Constructivist current in Paris.

In the early thirties, Calder made his first mobiles. These pioneering kinetic works were met with warm enthusiasm on both sides of the Atlantic, and Calder quickly won a place among the leaders of the international avant-garde—the first American sculptor to gain such acclaim.[13] Calder's unique fusion of non-objective art with the biomorphism of Miró and Arp, coupled with his own engineering expertise, produced a most astonishing and lasting body of work. Using movement to activate the surrounding space, Calder created an "environment" rather than a discrete object (Fig. 3). Volume is suggested through movement and a new dimension—time—is introduced. It was Calder's combination of the mechanical and the organic that opened up a whole new field of exploration for American sculptors.

Isamu Noguchi was also in Paris in the late twenties. Soon after his arrival in 1927, he began working as a part-time assistant for Constantin Brancusi. In 1928, Noguchi embarked on a series of abstract, highly polished zinc and brass constructions. While his respect for the natural properties of material was reinforced through his contact with Brancusi, he felt that Brancusi's art was too reduced and removed from the life and morphology he wanted in his own art. Arriving back in the United States in 1929, Noguchi was faced with the difficulty of supporting himself at a time when Americans were not particularly sympathetic to abstract art. As a result, he frequently turned to portrait commissions in bronze and terracotta. Nevertheless, his abstract works of the 1930s became models for the next generation of American abstractionists.

In addition to Calder and Noguchi, David Smith, Theodore Roszak, and Ibram Lassaw began to create innovative abstractions in the thirties, also in the form of geometric and biomorphic syntheses. Smith and Roszak were stimulated by their early experiences in Europe. In Prague during 1929–30, Roszak fell under the influence of the utopian ideals of the Bauhaus—a "pristine world of free and

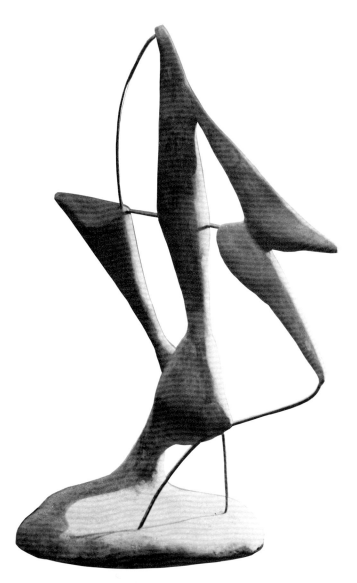

Fig. 5. Ibram Lassaw, *Concrete Abstraction*, 1934 (destroyed).
Concrete, approximately 36″ (91.4) high.

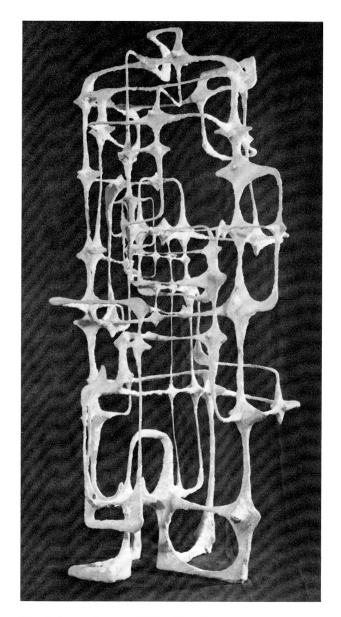

Fig. 6. Ibram Lassaw, *Milky Way/Polymorphic Space*,
1950. Plaster, 52 x 26 x 24″ (132.1 x 66 x 61 cm).
Collection of the artist.

unfettered objectivity."[14] Upon returning to the States, Roszak took courses in machine-shop techniques and began making sculpture through the processes of welding, screw-cutting, and machining. All the works were carefully tooled and constructed from slick, polished mechanical parts. Alluding to the work of Oskar Schlemmer, to streamline design, and futuristic fantasies of flight, these elegant and whimsical constructions range from the purely geometric to more biomorphic configurations (Fig. 4).

The machine aesthetic was similarly integral to the development of David Smith's sculpture in the thirties. Drawing on his early experience as a metal worker in an auto plant and his later interest in the direct-metal work of Picasso and Gonzalez in the late twenties, Smith assembled works in an additive fashion through direct welding.[15] He used discarded machine parts and scraps, thus extending the language of Cubist collage to include symbols of the industrial process. In 1932, he began two series of paintings—one Cubist-Surrealist inspired, the other incorporating found objects—and he briefly experimented with constructions of soldered aluminum, brass, tin, iron, and wire. In 1933, he established a workshop at Terminal Iron Works, Brooklyn, New York, and made his first group of welded steel sculptures—a series of heads.

Ibram Lassaw also experimented with welding in 1933, but would not use the process systematically for another twelve years. Lassaw was producing remarkably advanced abstract sculpture by the mid-thirties, expressive, open-form constructions made of wire and modeled plaster (Fig. 5). Affected by every major vanguard trend he encountered in exhibitions and art magazines, Lassaw's work in the thirties represents an amalgamation of these experiences. Though his strongest ties were to biomorphic Surrealism, particularly the free-form shapes of Arp, Miró, and Calder, his involvement with Constructivist ideas, through László Moholy-Nagy's *New Vision* (1932), led to his very early technical experiments with rubber, steel, acrylic, and Lucite.

By the mid-thirties in America, abstraction was beginning to take hold, and a small community of artists devoted to it formed. The two principal vehicles for this loose coalition were the WPA projects and the American Abstract Artists group. The WPA art projects provided many artists, including the abstractionists, with their only means of support during the Depression, allowing them to continue to work and even occasionally experiment. While on the projects, progressive sculptors such as Raoul Hague, Reuben Nakian, Louise Nevelson, David Smith, George Sugarman, Theodore Roszak, and Peter Agostini came into contact with their painter peers. The American Abstract Artists was founded in 1936 by a group of painters and sculptors protesting the exclusion of Americans from The Museum of Modern Art's 1936 exhibition "Cubism and Abstract Art." Formed primarily as an exhibiting society advocating the rights of abstractionists, over the next ten years, it provided a forum for discussions and a link to such important European exiles as Mondrian and Léger. Lassaw, one of the original members (and later the organization's president) admitted that he did not personally know another abstract sculptor until he met David Smith through the AAA in 1936.[16]

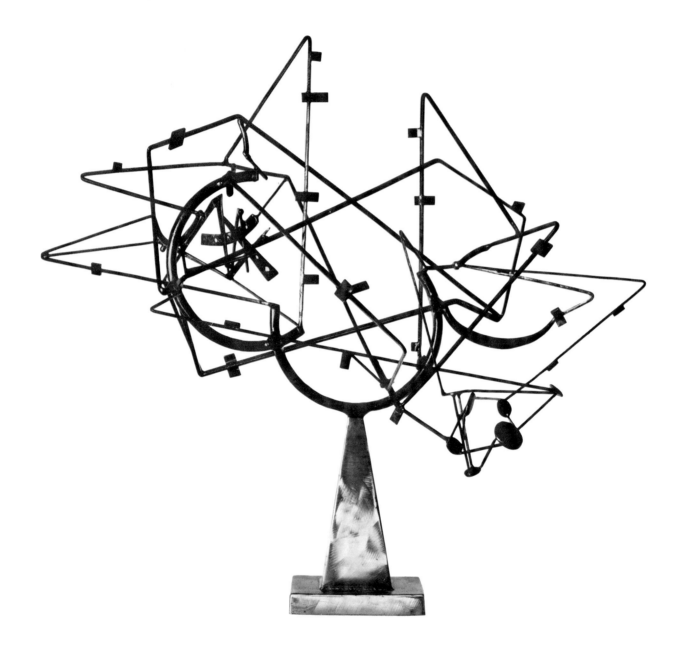

Fig. 7. David Smith, *Star Cage*, 1950. Painted welded metals, 44⅞ x 51¼ x 25¾″ (114 x 130.2 x 65.4 cm) including base. University Art Museum, University of Minnesota, Minneapolis; John Rood Sculpture Collection.

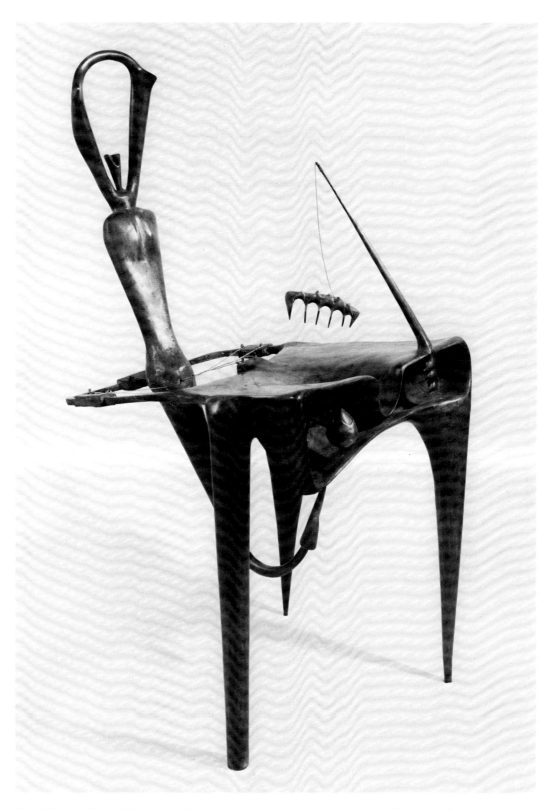

Fig. 8. David Hare, *Magician's Game*, 1944 (cast 1946). Bronze, 40¼ x 18½ x 25¼″ (102.2 x 47 x 64.1 cm). The Museum of Modern Art, New York; Given anonymously.

World War II temporarily disrupted this dialogue, but it had an unexpected effect on American attitudes toward abstraction. Until the Fascists rejected abstract art, it had been viewed as an expression of revolutionary ideologies. Now it was taken up and defended by the American media as the symbol of a free society.

As public interest in art rapidly expanded, an appeal was made for an advanced, innovative American art. In a letter to *The New York Times*, future art dealer Sam Kootz exhorted: "Anyhow, now's the time to experiment. You've complained for years about the Frenchman's stealing the American market. Well, things are on the up and up. Galleries need fresh talent, new ideas. Money can be heard crinkling through the land. And all you have to do, boys and girls, is get a new approach, do some delving for a change—God knows you've had a long rest."[17]

Kootz was surprised at the number of artists who responded to his call, prompting him to open the Kootz Gallery in 1945. His gallery (which showed Lassaw, Ferber, Hare, and Smith), along with those of Peggy Guggenheim, Charles Egan, and Betty Parsons, became the focal point in the 1940s for the newly developing painting and sculpture.

Peggy Guggenheim played a key role in publicly launching the postwar avant-garde. Her museum-gallery, Art of This Century, had been one of the few wartime havens for such exiled Surrealists as Matta, Yves Tanguy, Max Ernst, and André Masson, as well as the first to show the formative work of Arshile Gorky, Mark

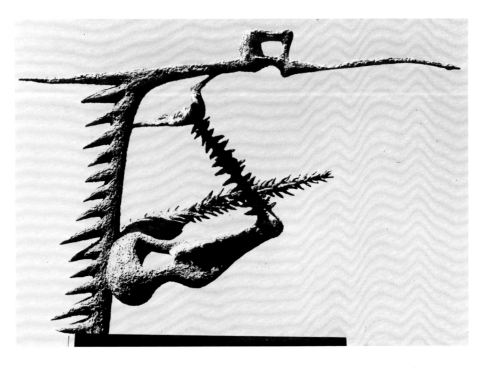

Fig. 9. Herbert Ferber, *Portrait of David Hare*, 1948. Lead, 23 x 33½ x 11½" (58.4 x 8.9 x 29.2 cm). Collection of the artist.

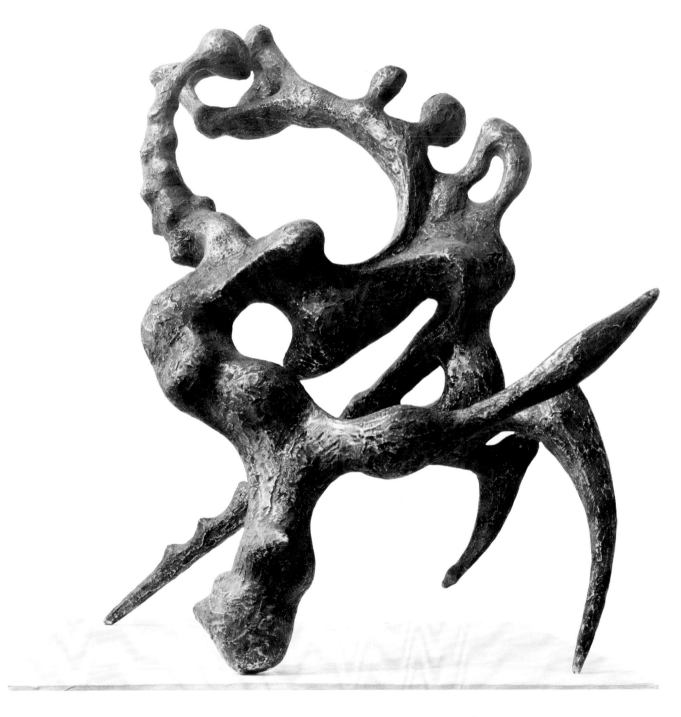

Fig. 10. Herbert Ferber. *Apocalyptic Rider*, 1947. Bronze, 44½ x 35 x 25″ (113 x 89 x 63.5 cm).
Grey Art Gallery and Study Center, New York University Art Collection; Anonymous Gift.

Rothko, Barnett Newman, Robert Motherwell, Jackson Pollock, and sculptor David Hare.

Though the presence of the Surrealists in New York was somewhat intimidating to American artists, it was an important stimulus nonetheless. The effects of Surrealism had already been felt by certain sculptors in the thirties, but with the benefit of a firsthand encounter, a Surrealist orientation came to dominate the best American sculpture of the forties.

Surrealism offered one solution for the need to infuse abstract art with personal, emotional content, but Americans had little use for the European program of nihilism, ambivalence, and complete capitulation to the unconscious. Instead, they adopted some of the Surrealist concerns—in particular, Surrealism's primitivizing impulse and formal characteristics—and combined them with other contemporary interests, namely, science and technology. The results ranged from the surrealistically transformed Bauhaus space constructions of Richard Lippold, Ibram Lassaw, and David Smith (Figs. 68, 6, 7) to the elegant, erotic, and playful Surrealism of Calder (Fig. 58), to the more aggressive, disquieting images of Roszak, Hare, Ferber, and Lipton (Figs. 8, 9, 10), to the powerful totemic presences and environments of Bourgeois, Noguchi, Smith, Kiesler, and Hare (Figs. 11, 12, 13, 47).

The idea of the totem—an object energized by magic and unconscious desire—absorbed an entire generation of artists through the forties and fifties. By its very definition a totem is an autonomous object, literally existing on the scale and in the materials in which it is made. The ritualized totem provided an emotionally charged, abstract figurative surrogate that circumvented figurative representation.

David Smith exploited the immediacy of the totem and its direct mode of address. For the freestanding Tanktotems (Fig. 12) he used boiler plates and tank tops. The totem's public and confrontational nature was emphasized through its open forms and lines and planes cutting into the space of the viewer. Noguchi fashioned equally imposing totemic figures of smooth interlocking stone shapes that evoke a powerful eroticism (Fig. 47). And in 1937, Calder began his series of large, sheet metal stabiles—stately, upright, vaguely anthropomorphic figures, often painted black. While suggesting both the primal and natural worlds, they also acknowledge the sophisticated machinery of twentieth-century technology. Louise Bourgeois, working in wood, carved biomorphic personages—often clustered in groupings—to create a mysterious, evocative environment (Fig. 11). Hare, Ferber, Lipton, and Roszak produced more disquieting presences, spiky, thorny, insect-vegetal hybrids in metal, reminiscent of such Surrealist works as Giacometti's *Woman with Her Throat Cut* (Fig. 14).

The direct-metal process of welding and brazing further extended the vocabulary of Surrealism in an expressionist direction, allowing for greater spontaneity and unconscious, aleatory effects. The oxyacetylene torch, perfected during the war, yielded practical benefits to sculptors. Unlike earlier torches, it was portable and relatively inexpensive and thus afforded a convenient method of working in accessible materials that were durable, ductile, and malleable. Any form—open or closed—could be modeled through the use of a torch, creating a highly textured effect that endowed the work with a "living," "restless," and metamorphosing

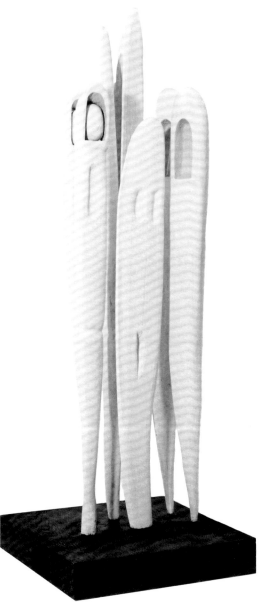

Fig. 11. Louise Bourgeois, *Quarantania*, 1941. Seven wooden pine elements, on wooden base, 84¾ x 31¼ x 29¼" (215.3 x 75 x 74.3 cm). Whitney Museum of American Art, New York; Anonymous gift 77.80.

Fig. 12. David Smith, *The Hero*, 1952. Painted steel,
73¹¹⁄₁₆ x 25½ x 11¾″ (187.2 x 64.8 x 29.8 cm). The
Brooklyn Museum; Dick S. Ramsay Fund.

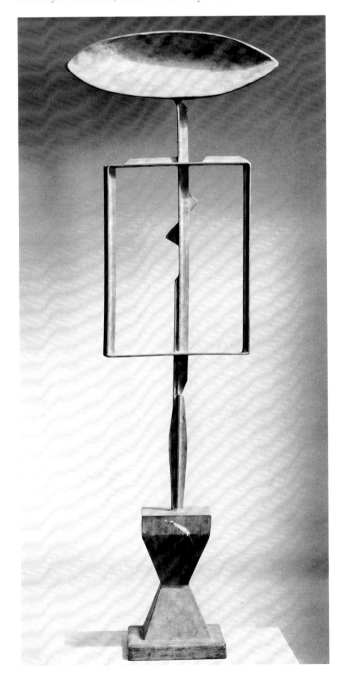

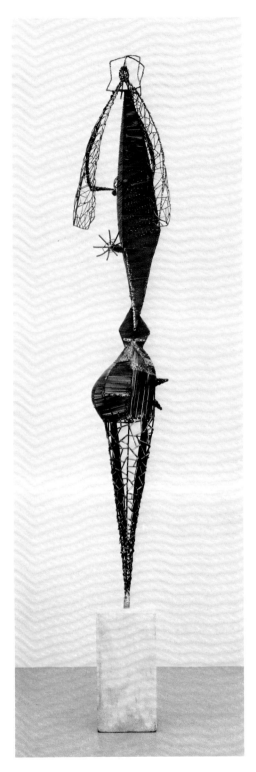

Fig. 13. David Hare, *Figure Waiting in
Cold*, 1951. Bronze and iron, on stone base,
71⅛ x 10½ x 11″ (182.6 x 26.7 x 27.9 cm).
The Museum of Modern Art, New York;
Given anonymously.

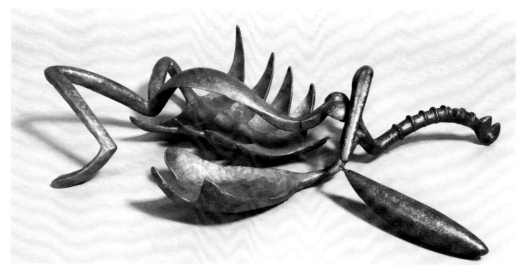

14

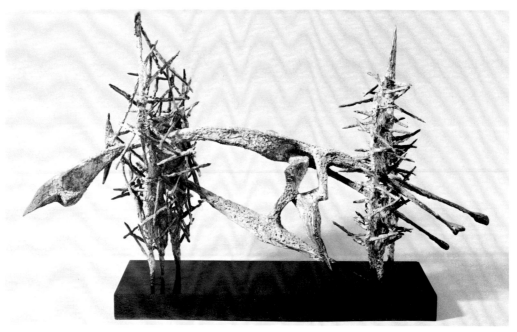

15

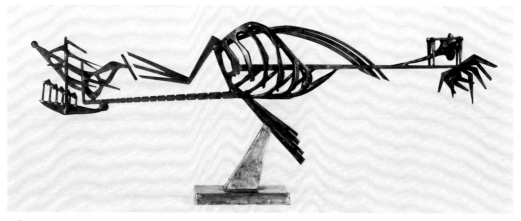

16

Fig. 14. Alberto Giacometti, *Woman with Her Throat Cut*, 1932. Bronze, 8 x 25 x 34½" (20.3 x 6.4 x 87.6 cm). The Museum of Modern Art, New York; Purchase.

Fig. 15. Herbert Ferber, *Jackson Pollock*, 1949. Lead with brass rods, 17⅝ x 30" (44.8 x 76.2 cm). The Museum of Modern Art, New York; Purchase.

Fig. 16. David Smith, *Royal Bird*, 1947–48. Steel, bronze, and stainless steel, 21¾ x 59 x 9" (55.2 x 149.9 x 22.9 cm) including base. Walker Art Center, Minneapolis; Gift of the T. B. Walker Foundation.

Fig. 17. Theodore Roszak, *Night Flight*, 1958. Steel, 96 x 125 x 58" (244.8 x 317.5 x 147.3 cm) including base. Collection of Mrs. T. Roszak.

Fig. 18. Herbert Ferber, *The Action Is the Pattern*, 1949. Lead with brass rods, 18" (45.7 cm) high. Collection of Kate and Christopher Rothko.

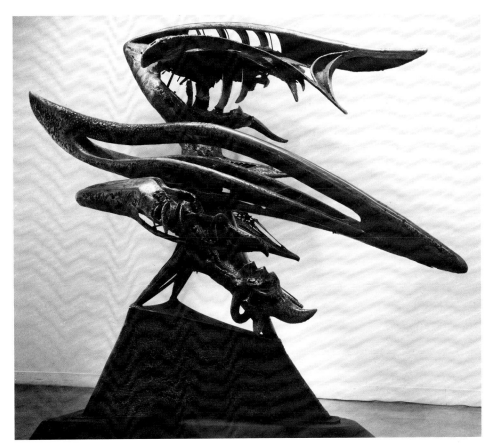

17

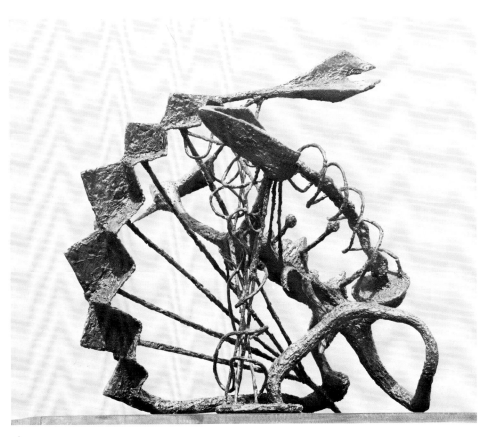

18

quality. The metaphoric implications of metal were likewise appreciated by artists, among them David Smith, who said "metal possesses little art history, what associations it does possess are those of this century: power, structure, movement, progress, suspension, brutality."[18] Also implicit, though unacknowledged, were associations of male conquest and domination. Theodore Roszak recognized the brutal, violent content of direct metal and used it to reinforce his abrupt shift in imagery following the war. Abandoning his earlier Constructivist ideals as innocent illusion, he turned to highly expressionist, mythic images in welded and brazed steel, such as *Spectre of Kitty Hawk* (Fig. 73). He announced that "The forms I find necessary to assert are meant to be blunt reminders of primeval strife and struggle, reminiscent of those brute forces that not only produced life, but in turn threaten to destroy it."[19]

World War II was largely responsible for the transformation of Surrealist reveries into violently charged images of destruction, rebirth, and mutation. As modern historical realities significantly enlarged "the imagination of disaster,"[20] New York artists searched for ways to make the primitive, Surrealist paradigm refocus the modern world view. An adequate response was needed to express the terror they felt in the face of a world where technology had passed beyond man's control.

The inevitability of nuclear power and the gradual adoption of an apocalyptic perspective generated the epic of nuclear death.[21] The drama of the possible extinction of the human species is very much in evidence in sculpture of the late forties and fifties, as it is in its popular culture counterpart, science fiction novels and films. Like many monsters of science fiction films, new sculptural images were based on imaginative crossbreedings of dinosaurs, predatory plants, pods, and blobs—nature gone berserk, grotesque mutations that represent an attempt to exorcise unbearable terrors by invoking and then subduing them.[22]

This shift to insistently violent imagery is apparent in sculpture in the theme of the apocalyptic bird (Figs. 15–18), which became prevalent from the late 1940s on. These menacing primeval images of "death from the skies," such as Roszak's *Night Flight* (Fig. 17), bear a strong resemblance to science fiction's airborne predators (Fig. 20), or to the prehistoric birds on view at New York's American Museum of Natural History (Fig. 21). The sculptures offer a startling contrast to the prewar utopian fantasies of flight (Fig. 19).

Atavism was one response to the growing dilemma of man's relationship to technology. But this reaction was soon joined by a movement in the opposite direction—toward the new frontiers of science. A fusion of primitive myth and the magic of modern science formed the basis of a new mythology—a new myth of genesis. Despite the increasingly real threat of extinction, there was a lingering positivist belief in scientific advances. The astounding discoveries in the field of nuclear physics, cytology, electron-microscopy, biology, and space exploration held a promise for survival and vastly stimulated the visual imagination.

The mounting interest in science surfaced in a new vitalist tendency in sculpture, a newfound faith in the regenerative power of nature. The process of natural

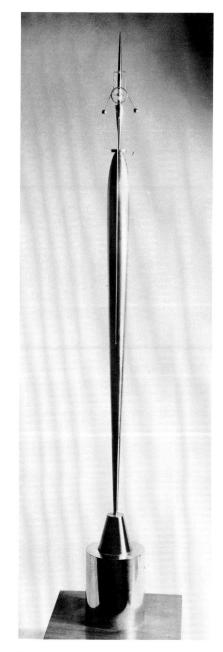

Fig. 19. Theodore Roszak, *Monument to Lost Dirigibles*, 1940. Steel and brass, 22 x 1¾ x 2¼″ (55.9 x 4.4 x 5.7 cm). Collection of Florence Roszak.

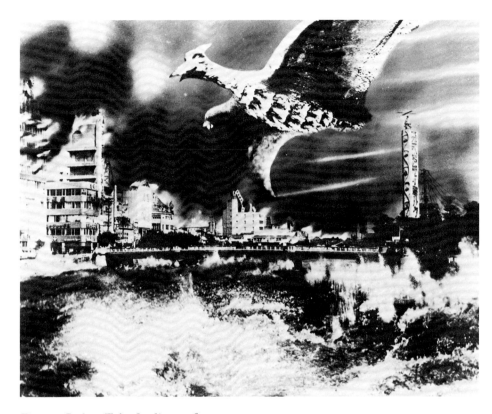

Fig. 20. *Rodan.* Toho Studio, 1956.

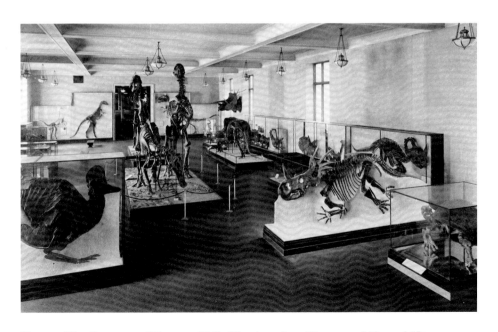

Fig. 21. The Cretaceous Dinosaur Hall. The American Museum of Natural History, New York.

growth was visualized as a momentous, primordial event and the process of making art became a metaphor for natural growth.[23]

Michael Lekakis has devoted his life to revealing the possibilities of growth contained in his chosen material of wood. Through an intuitive system of geometrized sections, he has worked to uncover the vital rhythm and biomorphic pattern inherent in the material. His carved wooden sculptures convey a dynamism and sense of breathing, pulsing, life (Fig. 22). He extended "entasis," the slight swelling of a classical Greek column, to describe the vital, generative quality that defines the presence of life and growth. The idea was expressed in terms of the "pulse" of a work—the opening and closing of forms.[24] In his search for a geometric representation of metabolic rhythms, Lekakis offers visual analogues to scientific forms. *Sympan* (Fig. 23), for instance, resembles the molecular structure of a protein.

Although influenced by the sensuous, undulating forms of Henry Moore (Fig. 24), Arp, and Brancusi, the new American vitalism surged forth in an aggressive, high-strung manner. The prewar, lyrical biomorphism gave way to a baroque expressionism, transformed by new materials and technological references, as well as by the recognition of mutation as a necessary adaptive survival strategy. As can be seen in Theodore Roszak's *Thorn Blossom* (Fig. 25), nature develops its own defense system: a tough, thorny shield to protect the delicate, vulnerable flower.

Fig. 22. Michael Lekakis, *Aiora*, 1958. Black pine, 20 x 71 x 18″ (50.8 x 180.3 x 45.7 cm). Collection of the artist.

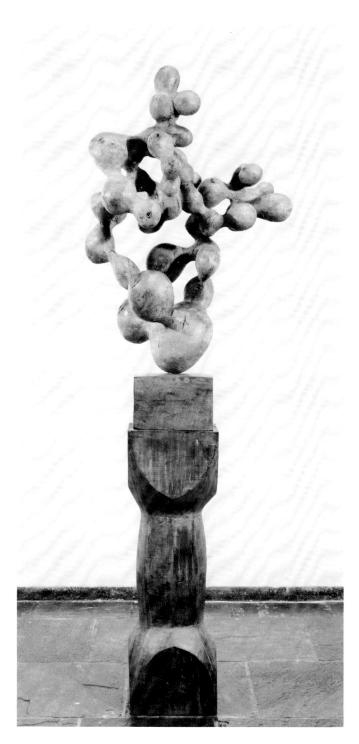

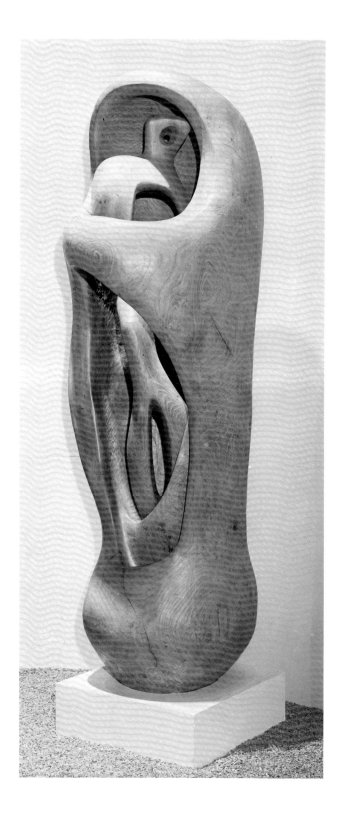

Fig. 23. Michael Lekakis, *Sympan*, 1960. Oak, 86 x 28 x 26″
(218.4 x 71.1 x 66 cm) including base. Whitney Museum of
American Art, New York; Gift of the Friends of the Whitney
Museum of American Art (and purchase) 61.33.

Fig. 24. Henry Moore, *Internal and External Forms*, 1953–54.
103 x 36″ (261.6 x 91.4 cm). Albright-Knox Art Gallery,
Buffalo; Purchase.

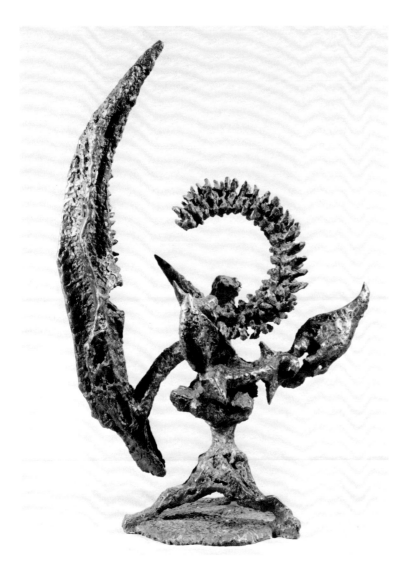

Fig. 25. Theodore Roszak, *Thorn Blossom*, 1948. Steel and nickel-silver, 33½ x 18½ x 22½" (85.1 x 47 x 57.2 cm). Whitney Museum of American Art, New York; Purchase 48.6.

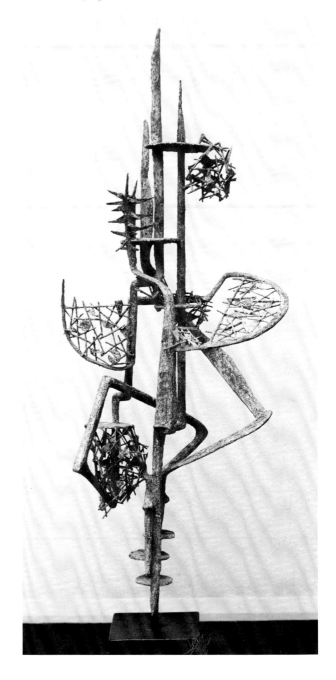

Fig. 26. Herbert Ferber, *The Flame*, 1949. Brass, lead, and soft solder, 65½ x 26 x 20" (166.4 x 66 x 51 cm). Whitney Museum of American Art, New York; Purchase 51.30.

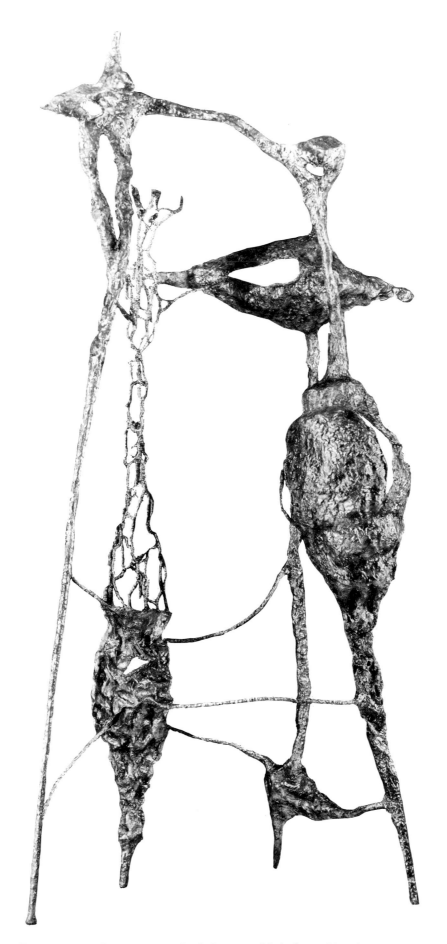

Fig. 27. Ibram Lassaw, *Quaternity*, 1956–58. Bronze, nickel-silver, silicon bronze, phosphorus and copper, 90 x 50 x 28″ (228.6 x 127 x 71.1 cm). Private collection.

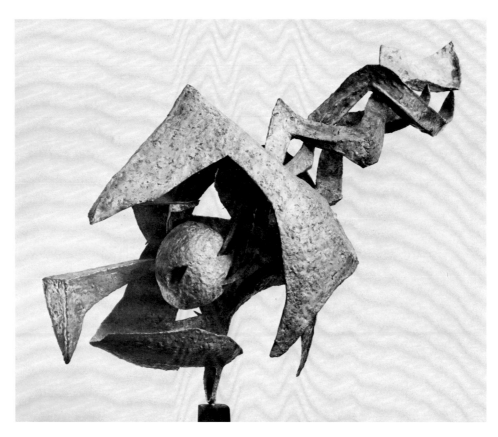

Fig. 28. Seymour Lipton, *Thunderbird*, 1951–52. Bronze on steel, 27½ x 36½ x 16″ (69.9 x 92.7 x 40.6 cm). Whitney Museum of American Art, New York; Wildenstein Benefit Purchase Fund 53.18.

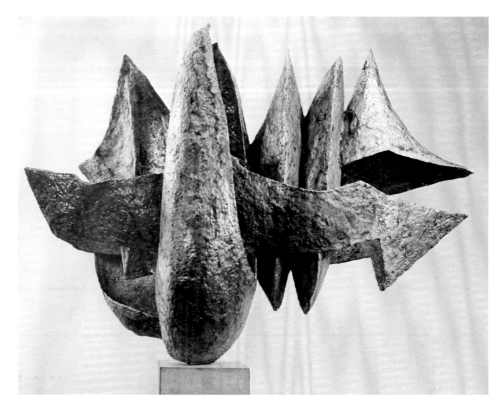

Fig. 29. Seymour Lipton, *Sea King*, 1955. Nickel-silver on Monel metal, 29½ x 42½ x 20″ (74.9 x 108 x 50.8 cm). Albright-Knox Art Gallery, Buffalo; A. Conger Goodyear Fund.

Through the manipulation of direct metal, a sensual yet repellent surface was achieved—one that said "touch but don't touch." The viscous metal further extended the metaphor of nature to suggest an oozing or scorched and excoriated skin, a surface implying birth and decay simultaneously (Figs. 26, 27, 28). Seymour Lipton recounted that "gradually the sense of dark inside, the evil of things, the hidden areas of struggle became for me a part of the cyclic story of living things. The inside and outside became one in the struggle for growth, death and rebirth in the cyclic renewal process. I sought to make a thing, a sculpture as an evolving entity: to make a thing suggesting a process."[25]

Lipton's invention of a radical and unique construction method made possible the play between inside and outside—internal and external anatomies, deep interior spaces and an irregular but organically continuous surface related to skin or bark. Brazing bronze and nickel-silver rods onto a sheared and bent sheet metal armature, Lipton was able to create and seamlessly oppose any geometric or organic form. This answered his need for an expansive vocabulary incorporating the interlocking polarities of biomorphic and technological shapes. *Sea King* (Fig. 29), for instance, refers to both a living form and a thrusting weapon or shield. In fact, Lipton admits armor as an important influence—a preindustrial model for the conflation of the biological and the mechanical.

Ibram Lassaw, who maintained a steady interest in science and science fiction, discovered that he could delve further into the recesses of deep space through welding. After modeling plaster compound around a wire cage in *Milky Way/Polymorphic Space*, a crucial transitional piece (Fig. 6), he realized that armature and surface could be fused through the use of a torch. Melting rods of different non-ferrous and ferrous alloys (such as brass, nickel-silver, stainless steel, phosphor bronze, silicon bronze, and iron), he produced intricate web-like structures and organic accretions with an extensive range of color and texture. Lassaw's open-space constructions, which are often named after stars, galaxies, and other celestial phenomena, represent a continuation of his earlier interest in fusing Constructivist geometries with biomorphic elements. In a curious rejoinder to Pollock's "I am nature," Lassaw asserts "I am space."

After Giacometti's *The Palace at 4 A.M.* (Fig. 30) was exhibited at The Museum of Modern Art in 1936, sculptors recognized that an architectural framework presented a promising alternative to figurative representation and a way to combine geometric and biomorphic forms. At once abstract and referential, the architectural structure can delimit space, define a stage or setting for interior events, or extend into and alter the real space of the viewer. The early "space cages" of Lassaw, Lipton, and Smith (Figs. 31, 32, 33) are metaphoric dreamscapes, abstract, ambiguous episodes contained within the frame.

The idea of architecture refocusing the scale of the viewer's space was taken up early on in another way by Frederick Kiesler in his work as a theoretical architect. In the early 1940s, he designed the inaugural exhibition for the Art of This Century Gallery, complete with curved walls, programmed lighting, and multipurpose furniture, to emphasize a fluid, "continuous" space. His quest for an in-

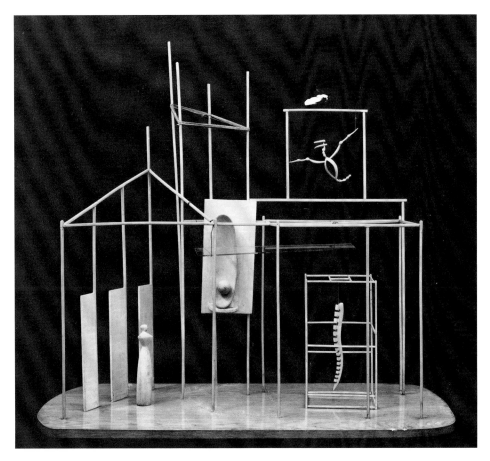

Fig. 30. Alberto Giacometti, *The Palace at 4 A.M.*, 1932–33. Construction in wood, glass, wire, and string, 25 x 28¼ x 15¾″ (63.5 x 71.8 x 40 cm). The Museum of Modern Art, New York; Purchase.

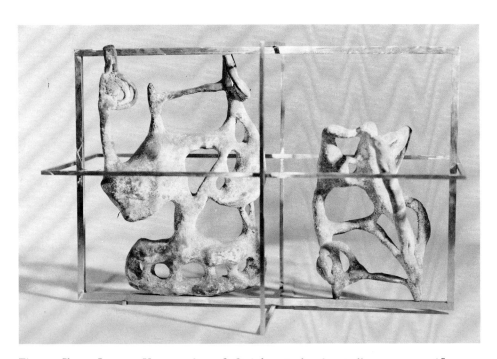

Fig. 31. Ibram Lassaw, *Uranogeod*, 1946. Stainless steel and cast alloy, 11 x 17 x 8″ (27.9 x 43.2 x 20.3 cm). Collection of the artist.

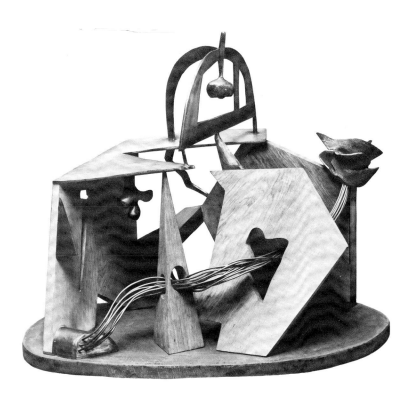

Fig. 32. Seymour Lipton, *Pavilion*, 1948.
Wood, copper, and lead, 24 x 14 x 25″ (61 x
35.6 x 63.5 cm). Collection of the artist.

Fig. 33. David Smith, *The Cathedral*, 1950.
Painted steel, 34⅛ x 24½ x 17⅛″ (86.7 x
64.8 x 43.6 cm). Private collection.

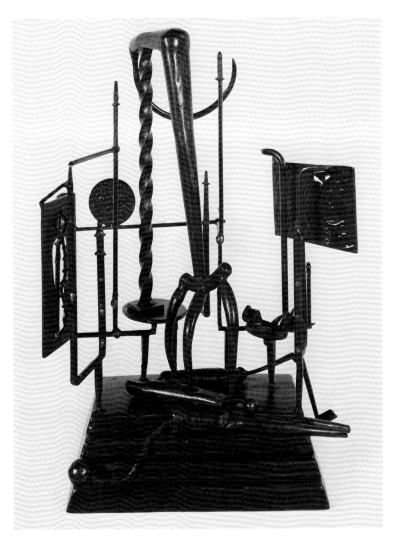

finitely expandable macrocosmic space led him to design his *Endless House* (Fig. 34), as well as some of the earliest environmental sculpture. "The object is no longer the main attraction," he wrote, "but becomes the environment itself."[26] In *Galaxy* (Figs. 35, 56), once part of a set for a Juilliard School production, Kiesler's three major interests in architecture, theater design, and sculpture converge.

The idea of creating or implying an environment encouraged other sculptors to think architecturally. One of the earliest proponents of an environmental art in America was Herbert Ferber. Following his Surrealist-inspired works of the forties, he moved into an increasingly abstract, formal mode, making his first direct-metal sculpture in 1945 to further the development of "open, airy, discontinuous forms, suspended in space."[27] In the early fifties, he began to put "roofs" on his sculpture, defining an architectural space within which calligraphic, linear elements could be oriented in any direction, unrestricted by gravity. *Roofed Sculpture with S-Curve* (Fig. 57) represents the genesis of Ferber's idea for a sculptured environment to walk through; it was eventually constructed in 1961 in the former quarters of the Whitney Museum on West Fifty-fourth Street (Figs. 58, 59).

Several artists were motivated to think on an "environmental scale" as a result of architectural commissions they received in the fifties. Sam Kootz, who took an active interest in both architecture and design, often initiated contacts between

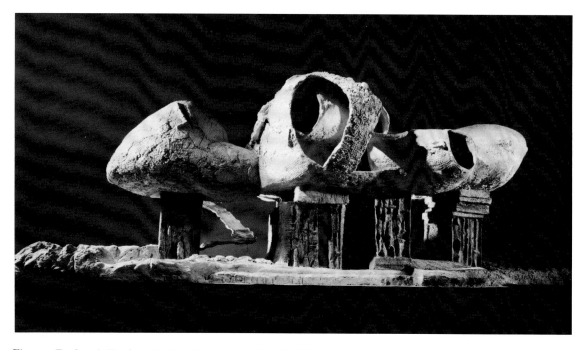

Fig. 34. Frederick Kiesler, *Endless House*, 1959–61. Model, cement over wire mesh, 38 x 96 x 42" (96.5 x 243.1 x 106.2 cm). Collection of Lillian Kiesler, courtesy Andre Emmerich Gallery.

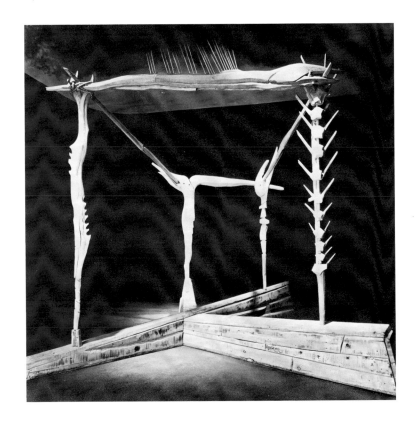

Fig. 35. Frederick Kiesler, *Galaxy*, 1951. Wood construction, 144 x 168 x 168″ (365.8 x 426.7 x 426.7 cm). Collection of Mrs. Nelson A. Rockefeller.

Fig. 36. Frederick Kiesler's set for Darius Milhaud's *Le Pauvre Matelot*. Juilliard School of Music, December 1948.

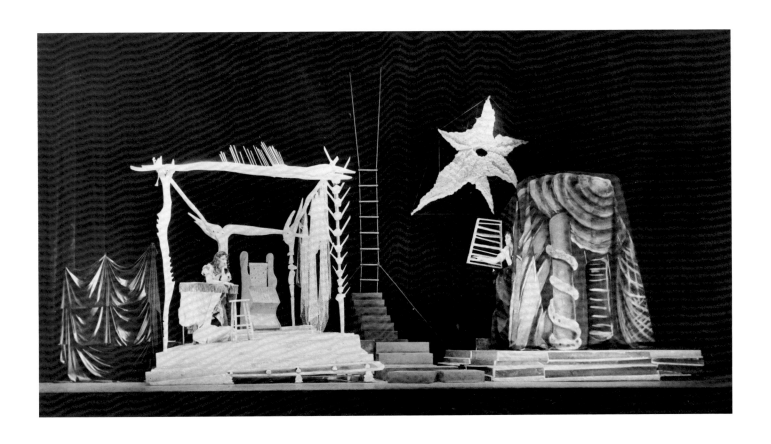

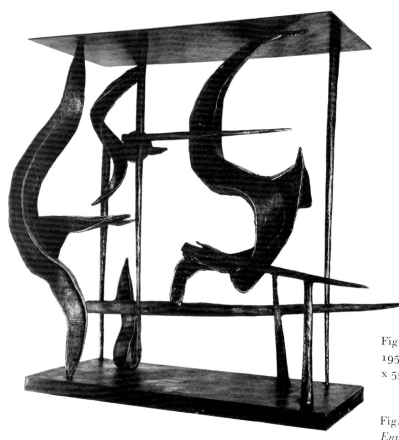

Fig. 37. Herbert Ferber, *Roofed Sculpture with S-Curve*,
1954–59. Bronze, 50½ x 60 x 22″ (128.3 x 152.4
x 55.9 cm). Collection of Edith Ferber.

Fig. 38. Herbert Ferber, Maquette for *Sculpture as
Environment*, 1960. Bronze and wood, 12 x 14 x 15″
(30.5 x 35.5 x 12.7 cm). Collection of the artist.

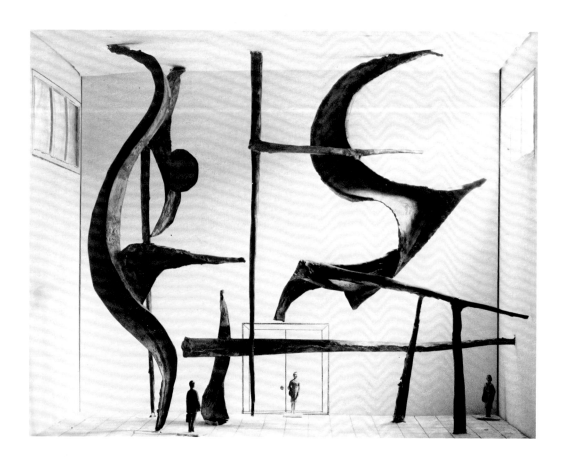

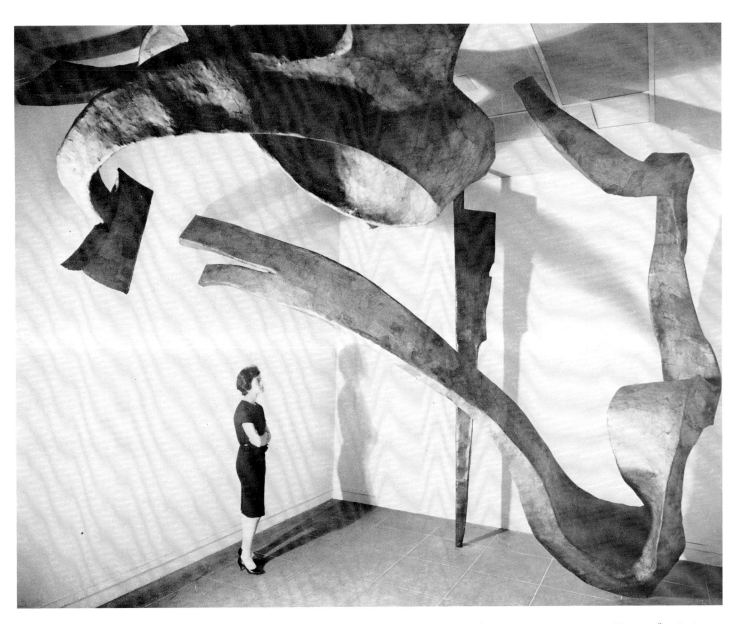

Fig. 39. Detail of *Sculpture as Environment* at the Whitney Museum of American Art, 1961. Papier-mâché, 144 x 288 x 180″ (365.8 x 731.5 x 457.2 cm).

Fig. 40. Louise Nevelson, *The Forest*, 1957. Installation at Grand Central Moderns, New York.

abstract artists and architects. A consummate businessman, he saw this activity as a potentially lucrative and virtually untapped source of income. After advertising his services to architects in trade journals, he arranged for several of his sculptors, including Lassaw, Hare, and Ferber, to secure large-scale sculptural commissions for institutional and private structures.[28] These included Lincoln Center (Max Abramovitz and Philip Johnson, architects); Congregation B'nai Israel in Millburn, New Jersey, and Congregation Beth El in Springfield, Massachusetts (Percival Goodman, architect). Ferber credits his 1951 commission for the Millburn synagogue (a commission shared with Adolph Gottlieb and Robert Motherwell) as a primary stimulus for formulating his sculptural ideas on a new scale.

Lipton and Roszak were also commissioned in the fifties to produce large-scale works, including Roszak's bell tower for M.I.T., completed in 1955. Noguchi, who had envisioned environmentally scaled projects in the thirties, realized the first of many such commissions in 1951, for the Reader's Digest Garden in Tokyo. This project came at the conclusion of a funded study trip, in which he examined the relationship of leisure to public spaces and, by extension, to *in situ* sculpture.

Concurrently, a different sort of environment was being formulated by Louise Bourgeois and Louise Nevelson, one in which the viewer's space was transformed by an aggregation of works. In 1949, Bourgeois had shown a series of totemic structures at the Peridot Gallery, installed to suggest a field or environment. The emphasis was not on the individual objects but rather on the emotional effect of the overall configuration, the psychological impact of these silent presences, or "personnages."

Nevelson, who considered metal construction "war-like," began to assemble bits of found wood during the war. She valued these wooden scraps for their availability and for the history of activity each piece contained. The wooden assemblages eventually led her, in 1958, to create the walls for which she is so well known. Constructed of wood and filled with found objects, they are simultaneously literal architecture and sculptural relief. *Sky Cathedral I* and *II*, part of a larger installation, were startlingly original works that extended sculpture into architectural and theatrical space. Like Bourgeois, Nevelson conceived of each exhibition as a totality, where objects were placed around the room to suggest another place and time, an evocative and emotional landscape (Fig. 40).

Though the interest in mythic themes and totemic presences persisted in the work of Nevelson and Bourgeois, their environments are symptomatic of an increasing preoccupation with abstract, formal concerns that gradually began to replace the lingering Surrealist imagery and its epidemic of biomorphism.

The use of junk materials was crucial in the transition to a more formally based sculpture: it resolved the problem of including subject matter in abstract sculpture. The material automatically carried its own content, but a cultural rather than a personal one. Hence, sculptors were free to conduct more ambitious formal experiments that closely paralleled New York School painting.

Richard Stankiewicz, a sculptor who based his early work on the use of found, rusted, junk metal, did much to shift the tone of sculpture in the mid-1950s, replacing high art formalities with humor, wit, and Dada irreverence. In *Kabuki*

Fig. 41. Gabriel Kohn, *Dunkirk*, 1960. Laminated wood, 22½ x 44" (57.2 x 111.8 cm). Whereabouts unknown.

Fig. 42. Mark di Suvero, *Hankchampion*, 1960. Wood and chains, 77½ x 149 x 105" (196.9 x 378.4 x 266.7 cm) overall. Whitney Museum of American Art, New York; Gift of Mr. and Mrs. Robert C. Scull 73.85.

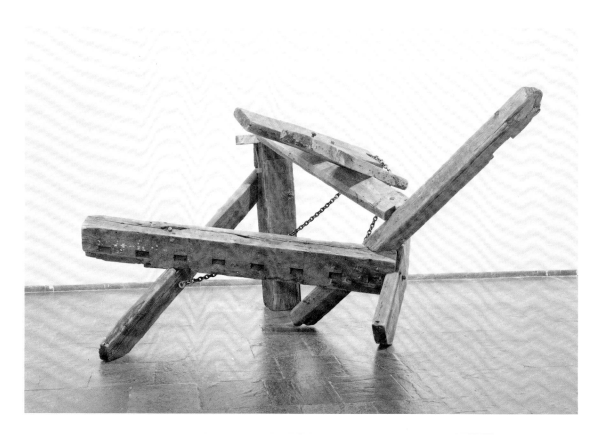

Dancer (Fig. 75), hubcaps, radiators, and other rusted entrails are resurrected in a lively, figural posture. His magical transformation of detritus opened the door for other artists to boldly experiment with cast-off remnants.

Mark di Suvero, using discarded construction materials, worked in an additive, improvisational manner to emphasize gesture, process, and dynamic extension. In *Hankchampion* (Fig. 42), large timbers are assembled to suggest a frozen gesture that belies the scale and weight of the materials. Speed and velocity are implicit in the prior life of Chamberlain's crushed auto bodies. He further emphasizes this quality through his spontaneous and somewhat erotically charged method of "fitting" the pieces together. Chamberlain's use of interlocking auto parts also allowed him to incorporate color naturally (Fig. 53). Together with David Smith and George Sugarman, he made an important contribution to the revival of polychromy in the late 1950s.[29] In Sugarman's *Yellow Top* (Fig. 54)—as in Chamberlain's and Smith's work—color is not used to illustrate, but to clarify relationships between forms and to introduce the pictorial issues of foreground/background and surface/support.

Sugarman, Chamberlain, di Suvero, Agostini, Bontecou, and Gabriel Kohn (Fig. 41) moved beyond the figurative allusions and implied narratives of the sculpture that immediately preceded them. They wanted to avoid the suggestion of "statue" by creating a new kind of object, extended in space and free of personal and metaphoric reference. These sculptors rejected the "oracular" aspects of Abstract Expressionism in favor of its formal and methodological means—its scale, drama, and confrontational address. This increasingly formalist drive and tendency toward an abstraction purged of any reference led sculpture into a more autonomous, self-reflexive phase. The literalism that had once been sculpture's handicap now gave it a distinct advantage and, as Greenberg noted, an infinity of new self-evident forms "as palpable and independent and present as the homes we live in and the furniture we use."[30]

The historical position of New York School sculpture was denied by its Minimalist successors, who were obsessed with the purity and essential objectness of sculpture. But, in time, Minimalist orthodoxy came to seem as oppressive, constraining, and academic as monolithic carving had seemed to vanguard sculptors of the early 1940s.

Today, a new generation of sculptors is returning to the pre-Minimalist era—to the forties and fifties—for sources and stimulation. There they have found work compatible with contemporary concerns: work that is ambiguous, both abstract and imagistic; work that contains sex and humor without depending on narrative; that is physical, robust, gestural and organic, mystical and moral. As Frank Stella has recently noted, "Today, abstraction struggles, at least partly, because it has failed to come up with a really viable substitute for human figuration. . . . It's very hard for abstraction or abstract figuration to be sexy, and if it's not sexy, it's not art. Everyone knows that."[31] In light of recent arrivals (Figs. 43–46), it has become critical to re-examine the sculpture of the late forties and fifties, to discover the old in the new and recover the new in the old.

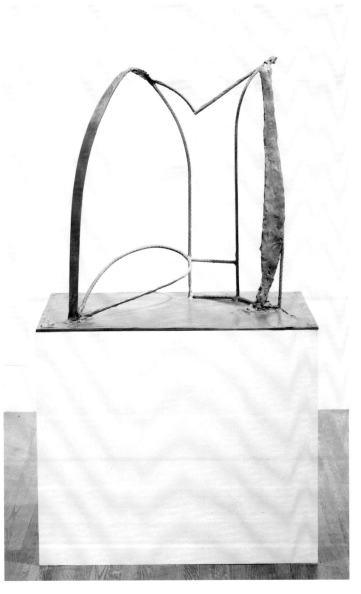

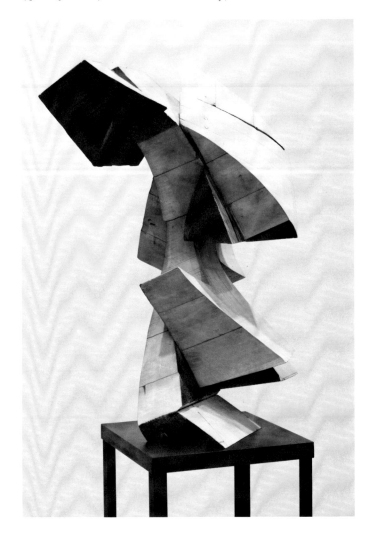

Fig. 44. Mel Kendrick, *Untitled (Red and Black)*, 1983. Charcoal, colored pencil, ink, and acrylic on wood, 33 x 17 x 20½″ (83.8 x 43.2 x 52.1 cm). Blum Helman Gallery, New York.

Fig. 43. Bryan Hunt, *Reclining Linear*, 1982. Cast bronze, on limestone base, 71 x 41¼ x 23½″ (180.3 x 104.8 x 59.7 cm). Blum Helman Gallery, New York.

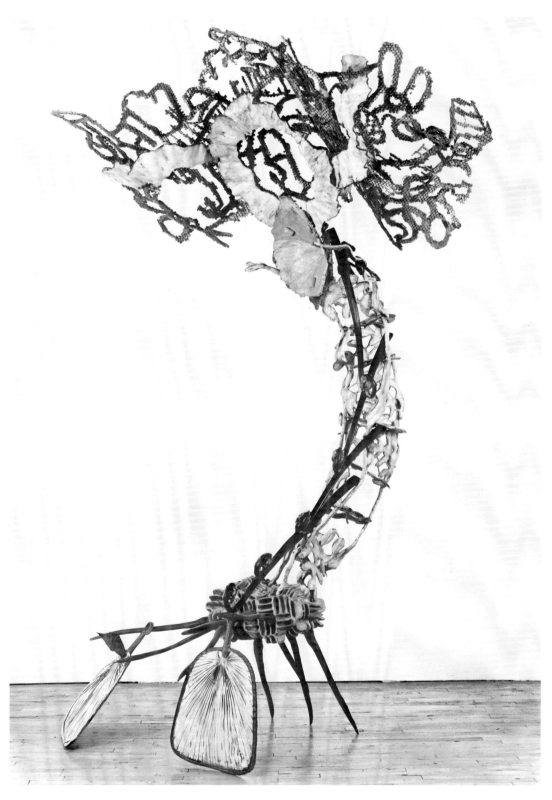

Fig. 45. Nancy Graves, *Cantileve*, 1983. Bronze with polychrome patina, 98¾ x 67 x 55″ (250.8 x 170.2 x 139.7 cm). Whitney Museum of American Art, New York; Purchase, with funds from the Painting and Sculpture Committee 83.39.

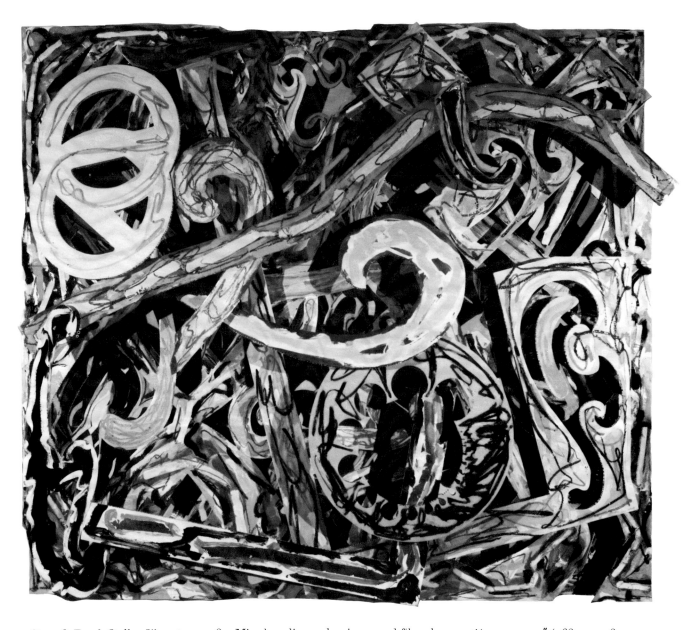

Fig. 46. Frank Stella, *Silverstone*, 1981. Mixed media on aluminum and fiberglass, 105½ x 122 x 22″ (268 x 292.8 x 55.9 cm). Whitney Museum of American Art, New York; Purchase, with funds from the Louis and Bessie Adler Foundation, Inc., Seymour M. Klein, President; the Sondra and Charles Gilman, Jr. Foundation, Inc.; Mr. and Mrs. Robert M. Meltzer; and the Painting and Sculpture Committee 81.26.

NOTES

1.
James Thrall Soby, "The Younger American Artists," *Harper's Bazaar*, 81 (September 1947), p. 194.

2.
Clement Greenberg, "The New Sculpture," *Partisan Review*, 16 (June 1949), p. 639.

3.
Serge Guilbaut, *How New York Stole the Idea of Modern Art: Abstract Expressionism, Freedom, and the Cold War* (Chicago: The University of Chicago Press, 1983), p. 98.

4.
Greenberg, "The New Sculpture," p. 641.

5.
This remark is commonly attributed to Ad Reinhardt, who was also said to have referred to sculpture as "the thing you park your ashtray on."

6.
Willem de Kooning, quoted in Dore Ashton, *The New York School: A Cultural Reckoning* (New York: Penguin Books, 1980), p. 200.

7.
See Ashton, ibid.; Harold Rosenberg, *The Tradition of the New* (New York: Horizon Press, 1959) and *The Painters and Sculptors of the Fifties* (New York: Harper & Row, 1978); Barbara Rose, *American Art Since 1900: A Critical History* (New York: Praeger Publishers, 1967); Sam Hunter, *Modern American Painting and Sculpture* (New York: Dell, 1959); and Robert Goldwater, "Reflections on the New York School," *Quadrum*, 8 (1960), pp. 17–36.

8.
Clement Greenberg, "Sculpture in Our Time," *Arts*, 32 (June 1958), pp. 22–25.

9.
Wayne Andersen, "The Fifties," *Artforum*, 5 (Summer 1967), p. 61

10.
Herbert Read, *A Concise History of Modern Sculpture* (New York: Praeger Publishers, 1964), p. 230

11.
Harold Rosenberg, "The Art Galleries: On Art Movements." *The New Yorker*, October 5, 1963, p. 161.

12.
Joan M. Marter, Roberta K. Tarbell, and Jeffrey Wechsler, *Vanguard American Sculpture 1913–1939*, exhibition catalogue (New Brunswick, New Jersey, Rutgers University Art Gallery, 1979), p. 11. Of the thirty-five Americans in the show, only two—Gaston Lachaise and Andrew Dasburg—exhibited anything remotely "modern." The rest were firmly entrenched in the academic tradition. Prior to 1930, those who chose to follow a non-objective course could be counted on one hand.

13.
Calder was the only American in The Museum of Modern Art's 1936 exhibitions "Cubism and Abstract Art" and "Fantastic Art, Dada and Surrealism."

14.
This description of the Bauhaus ideal is that of Theodore Roszak, quoted in Joan Pachner, "Theodore Roszak and David Smith: A Question of Balance," *Arts*, 58 (February 1984), p. 104.

15.
Smith became acquainted with Gonzales' welded works through the French journal *Cahiers d'art* and through his friend the painter John Graham, a member of the Paris-based Cercle et Carré group, of which Gonzales was also a member. Graham made regular visits to Paris, brought sculptures back with him, and made a gift of Gonzales' *Mask* to Smith in 1934.

16.
Ibram Lassaw, "Perspectives and Reflections of a Sculptor: A Memoir," *Leonardo*, 1 (1968), p. 353.

17.
Sam Kootz, letter to *The New York Times*, August 10, 1941, Kootz Papers, Archives of American Art, New York, no. 1318.

18.
David Smith, quoted in the typescript of The Museum of Modern Art's 1952 panel, "The New Sculpture: A Symposium," p. 7.

19.
Theodore Roszak, quoted in ibid., p. 18.

20.
Susan Sontag, "The Imagination of Disaster" (1966), reprinted in *Against Interpretation* (New York: Dell, 1969), pp. 212–28.

21.
Paul Virilio and Sylvere Lotringer, *Pure War* (New York: Semiotext(e), 1983), p. 63.

22.
Sontag, "The Imagination of Disaster," p. 218.

23.
The vitalist tendency was accelerated, in large part, because of the artists' long-standing interest in the natural sciences. Lipton and Ferber had studied science in preparation for dentistry; Hare had studied medicine and briefly worked as a medical photographer; Calder and Roszak were trained as engineers; Lassaw and Lekakis read extensively in biology and physics. All were stimulated by visits to the American Museum of Natural History, where the worlds of natural science and primitive culture coexisted. For further discussion, see Jeffrey Weiss, "Science and Primitivism: A Fearful Symmetry in the Early New York Science Museum School," *Arts Magazine*, 57 (March 1983), pp. 81–87.

24.
Joseph Margolis, "Michael Lekakis and the 'Heuristics of Creation,'" *Main Currents in Modern Thought*, 31 (March-April 1975), pp. 107–14.

25.
Quoted in Andrew Carnduff Ritchie, "Seymour Lipton," *Art in America*, 44 (Winter 1956–57), p. 15.

26.
Frederick Kiesler, "The Future: Notes on Architecture as Sculpture," *Art in America*, 54 (May-June 1966), p. 68.

27.
Herbert Ferber, "On Sculpture," *Art in America*, 42 (December 1954), p. 263.

28.
Kootz Papers, Archives of American Art, New York, no. 1318.

29.
Smith and Roszak, who began as painters, are significant antecedents to the revival of polychromy in the fifties. Early on they became strongly attached to pictorial concerns, as evident in their use of applied color, as well as in their linear compositions. In addition, Calder, Ferber, and Chamberlain started as painters, and it should be remembered that, beginning with Picasso's *Guitar*, painters have consistently made a contribution to the development of sculpture in the twentieth century.

30.
Greenberg, "The New Sculpture," p. 641.

31.
Frank Stella, "Working Space," The Charles Eliot Norton Lectures. Harvard University, Cambridge, Massachusetts, February 6, 1984.

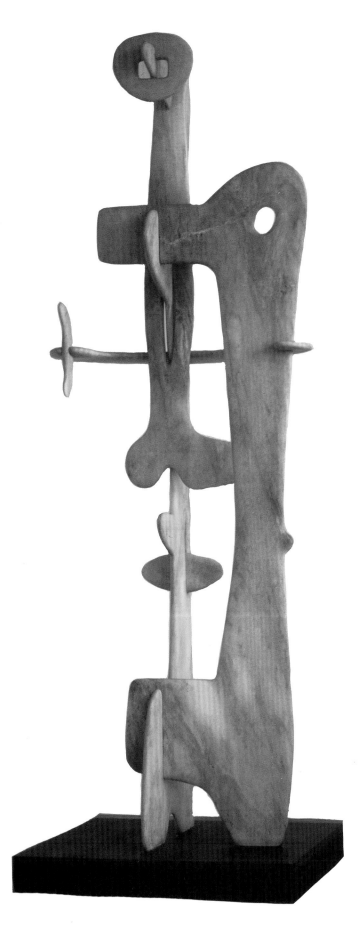

Fig. 47. Isamu Noguchi, *Kouros*, 1944–45. Pink Georgia marble, on slate base, 117″ (297.2 cm) high. The Metropolitan Museum of Art, New York; Fletcher Fund.

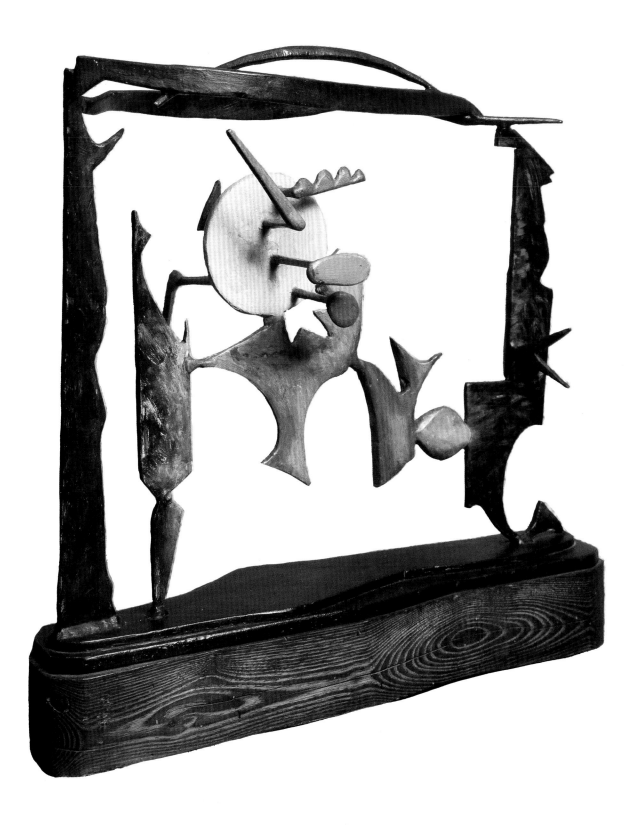

Fig. 48. David Smith, *Helmholtzian Landscape*, 1946. Painted iron, on wooden base, 18⅜ x 19 x 7⅜″ (46.7 x 48.3 x 19.7 cm). Collection of Mr. and Mrs. David Lloyd Kreeger.

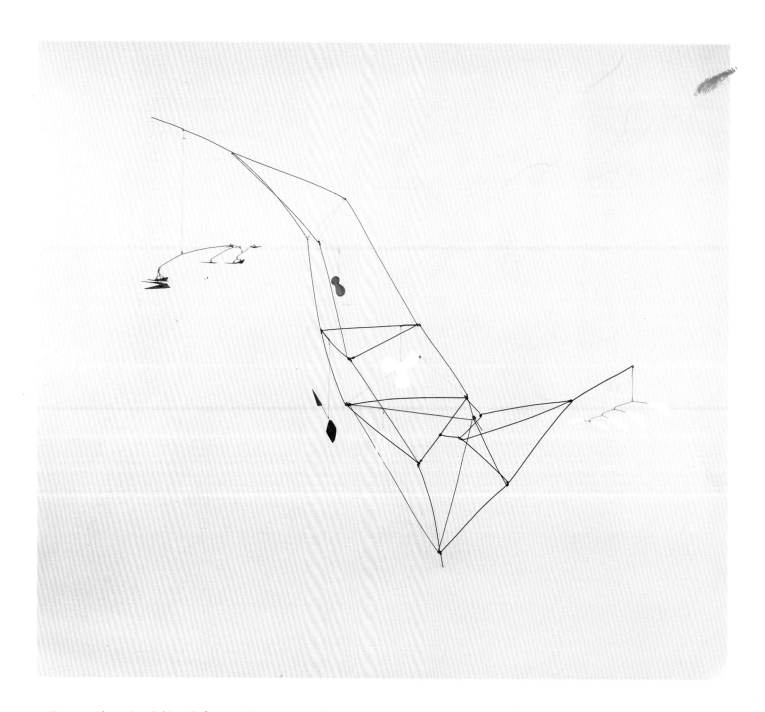

Fig. 49. Alexander Calder, *Bifurcated Tower*, 1950. Painted metal and wire, 58 x 72 x 53″ (147.3 x 182.9 x 134.6 cm) irregular. Whitney Museum of American Art, New York; Gift of the Howard and Jean Lipman Foundation, Inc. (and exchange) 73.31.

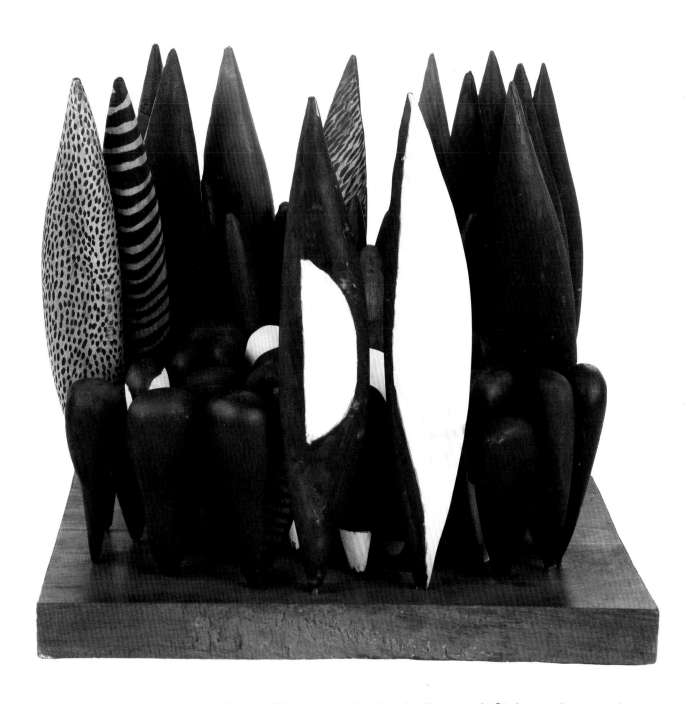

Fig. 50. Louise Bourgeois, *One and Others*, 1955. Painted wood, 18¼ x 20 x 6¾″ (46.4 x 50.8 x 42.5 cm). Whitney Museum of American Art, New York; Purchase 56.43.

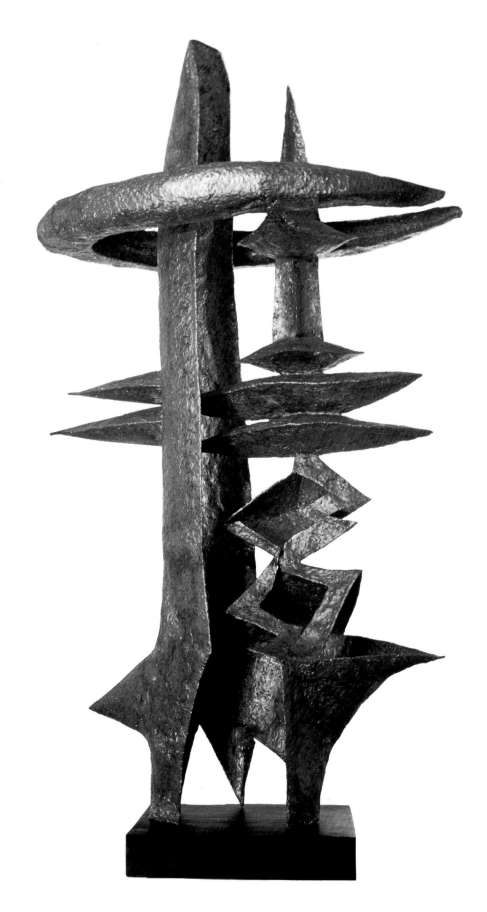

Fig. 51. Seymour Lipton, *Sorcerer*, 1957. Nickel-silver on Monel metal, 60¾ x 36 x 25″ (154.3 x 91.4 x 63.5 cm). Whitney Museum of American Art, New York; Gift of the Friends of the Whitney Museum of American Art 58.25.

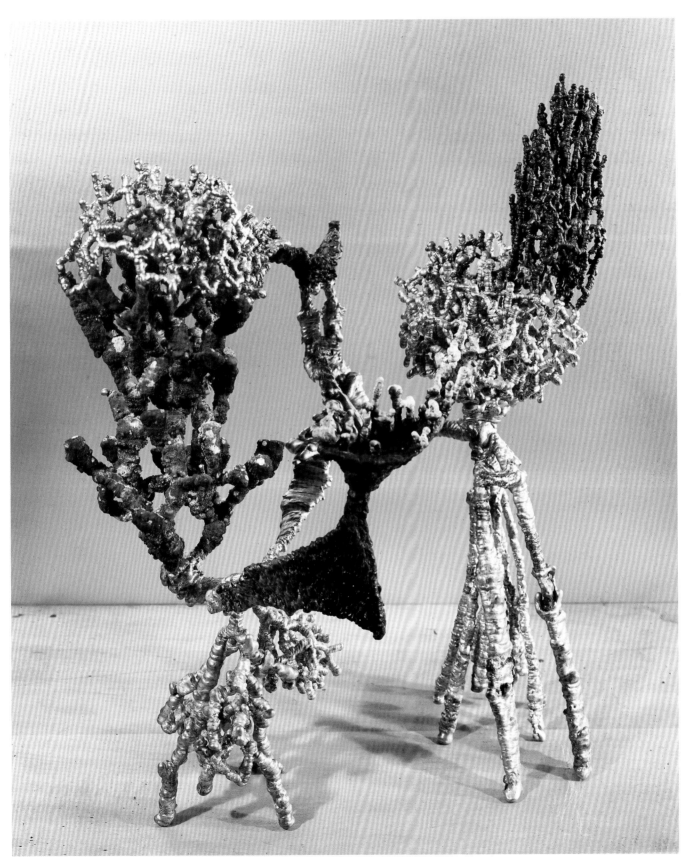

Fig. 52. Ibram Lassaw, *Antipodes*, 1960. Various alloys, 21 x 16 x 11½″ (53.3 x 40.6 x 29.2 cm).
Collection of Ernestine Lassaw.

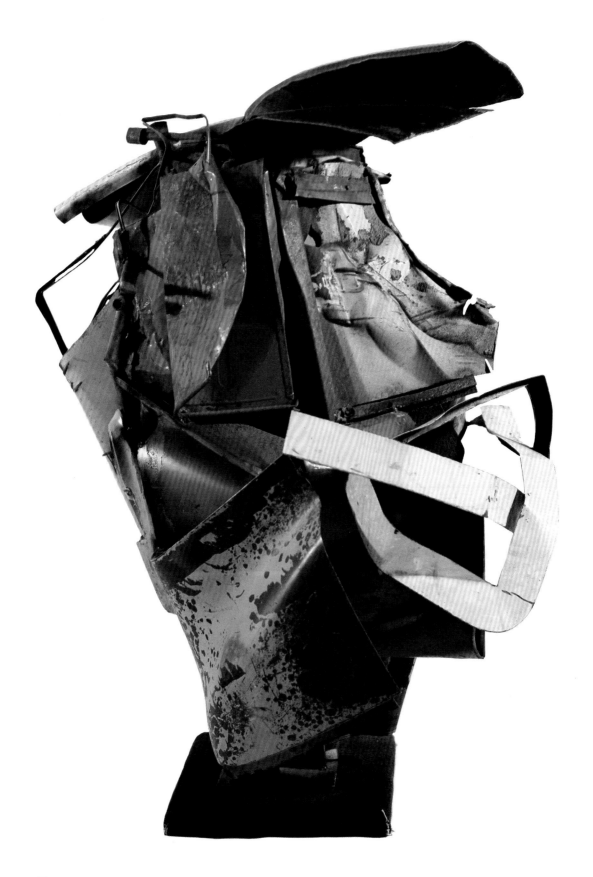

Fig. 53. John Chamberlain, *Johnnybird*, 1959. Enameled steel, 59 x 53 x 45½″ (149.9 x 134.6 x 115.6 cm).
Collection of Sydney and Frances Lewis.

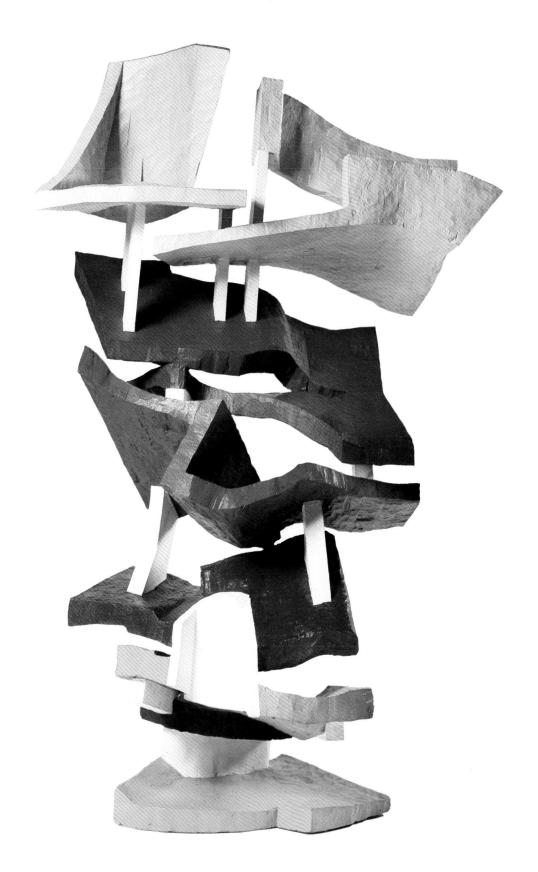

Fig. 54. George Sugarman, *Yellow Top*, 1960. Laminated wood, polychromed, 87½ x 54 x 34″ (222.3 x 137.2 x 86.4 cm). Walker Art Center, Minneapolis; Gift of the T. B. Walker Foundation.

Peter Agostini

Born 1915

Born in New York City. Agostini studied briefly at New York's informally run Leonardo da Vinci School. While employed by the WPA in the 1930s, he met artists who would later become leading Abstract Expressionists—Jackson Pollock, Lee Krasner, Franz Kline, and Willem and Elaine de Kooning. In the forties and fifties, Agostini worked as a commercial artist for several women's clothing stores and for the U.S. Army Quartermaster Corps. He taught at Columbia University, New York (1961–66); since 1966, he has been teaching at the University of North Carolina at Greensboro.

Agostini's early sculpture was in terracotta and plaster and consisted mainly of small modeled figures—heads, busts, and horse and rider groups—that have been compared to the work of the late Impressionist Medardo Rosso. Through the fifties, Agostini worked primarily with plaster models, some of which were cast in bronze, and often focused on sea themes. After 1959, he began to concentrate on the inherent properties of plaster. He worked with such diverse materials as balloons, corrugated cardboard, and crumpled aluminum, into which fast-drying plaster could be poured to form a "positive" impression. This method required great speed and dexterity and provided spontaneity and expressive immediacy. Because the poured plaster pieces of this period preserved such chance effects as drips and handprints, and thus retained evidence of the artist's involvement in their creation, they were compared with contemporary efforts to achieve gestural freedom in painting; Agostini was even called an Action Sculptor. By the mid-1960s, as the range of materials he was casting from increased, and as he became more interested in illusionistic tableaux and in such confounding images as cast plaster balloons, he was identified as a Pop artist, linked with George Segal, Jasper Johns, and Claes Oldenburg. Toward the end of the decade, Agostini began a series of sensual, abstracted female figures, formed from casts of swollen, twisted rubber tubes. He returned to modeling and to casting in bronze in the 1970s, creating first a series of heads—some naturalistic, others more stylized—and then a group of full-length figures of elderly men.

Agostini had his first one-artist show at the Galerie Grimaud, New York, in 1959 and has had several subsequent shows in New York and Chicago. He was one of several artists to receive a commission for the exterior of the New York State Pavilion at the 1964–65 World's Fair in New York. In 1974, the Comfort Gallery of Haverford College presented an extensive retrospective of his sculpture.

Agostini's work was initially shown at the Whitney Museum in its 1959 Longview Foundation Purchases exhibition and has been seen there in seven shows since. The Museum owns one sculpture by Agostini, acquired in 1966.

Fig. 55. Peter Agostini, *Clouds*, 1959–60. Plaster, 16 x 11½ x 11½″ (40.6 x 29.2 x 29.2 cm). Collection of the artist.

Agostini, Peter, and Robert Mallary. "Is Sculpture a Step-Child?: A Colloquoy." *Art News*, 63 (September 1964), pp. 40–42.

Goldstein, Carl. "The Direct Cast and Sculpture." *Arts Magazine*, 50 (January 1976), pp. 86–89.

———. "Peter Agostini." *Arts Magazine*, 50 (April 1976), p. 16.

H[ess], T[homas] B. "Peter Agostini: The Sea and the Sphere." *Art News*, 58 (March 1959), pp. 35, 65.

Kozloff, Max. "New York Letter." *Art International*, 6 (September 1962), pp. 33–35.

Navaretta, E. A. "Agostini Makes a Sculpture." *Art News*, 61 (May 1962), pp. 27–30.

P[etersen], V[alerie]. "Two Sculptors, Two Painters for December." *Art News*, 59 (December 1960), pp. 36–37, 59.

Recent American Sculpture (exhibition catalogue). Article by Max Kozloff on "Peter Agostini." New York: The Jewish Museum, 1964, pp. 8–11.

S[andler], I[rving] H. "Agostini: High-Speed Plaster." *Art News*, 62 (Summer 1963), pp. 29, 68.

Silver, Jonathan. "Haverford: A Sense of Human Motion." *Art News*, 73 (September 1974), p. 81.

Stein, Judith. "Peter Agostini at the Comfort Gallery, Haverford College." *Art in America*, 62 (July-August 1974), p. 94.

Tillim, Sidney. "Month in Review: Agostini's Rococo *cum* Dada." *Arts*, 35 (January 1961), pp. 48–49.

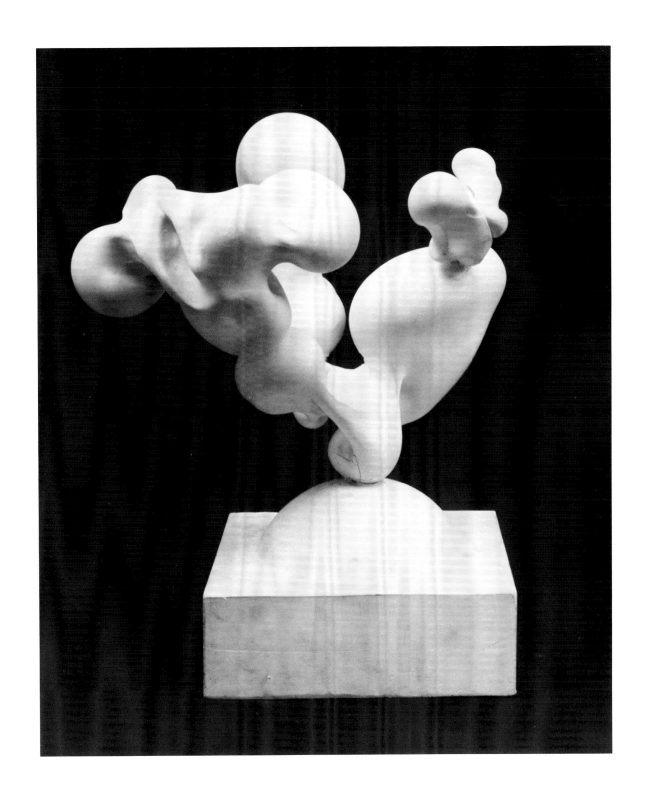

Lee Bontecou

Born 1931

Born in Providence, Rhode Island. Bontecou grew up in Nova Scotia, Canada, and Westchester, New York. She studied at the Art Students League from 1952 to 1955 with William Zorach and John Hovannes and at the Skowhegan School of Painting and Sculpture in Maine during the summer of 1954.

Initially a figurative sculptor, Bontecou worked with plaster, terracotta, and then bronze in the late fifties, attaching sections of these materials to metal armatures in a manner that suggested armor plate. The aggressive, even threatening character of this sculpture—which suggested vaguely atavistic birds and animals —was sustained in the relief works that followed starting in 1959. In these reliefs, which firmly established her reputation, Bontecou stretched canvas across a complex framework of metal rods, sometimes shading the fabric with soot and charcoal. The clearly articulated surface patterns of the reliefs, in which the influence of Pacific Northwest Indian sculpture can be seen, were dominated by fractured arcs converging around menacing black voids.

By the early sixties, Bontecou's work incorporated sawblades, zippers, pieces of screen, wire, rope, and other miscellaneous hardware that enhanced its predatory nature. These reliefs were acclaimed as among the first three-dimensional forms to successfully mediate between painting and sculpture. In 1967, she returned to figuration, creating carefully observed fish and more stylized flowers of vacuum-formed plastic. Recently, she has been working mainly in graphic media, with which she has always been deeply involved.

Bontecou had her first one-artist exhibition in 1959. A year later, she had a solo show at the Leo Castelli Gallery, which has represented her work ever since. In 1964, she was awarded a prized commission for a relief sculpture at the New York State Theater, Lincoln Center, New York. The Museum of Contemporary Art, Chicago, presented a retrospective of her work in 1972, and she has exhibited extensively in Europe as well.

Bontecou's work was first seen at the Whitney Museum in its 1964 "Friends Collect" exhibition, and has been included in seven shows since. The Museum owns one drawing, one print, and one sculpture by Bontecou; the last entered the Permanent Collection in 1961.

Fig. 56. Lee Bontecou, *Untitled*, 1960. Welded steel and canvas, 55 x 66½ x 20″ (139.7 x 168.9 x 50.8 cm). Collection of Mrs. Albert List.

Ashton, Dore. "Unconventional Techniques in Sculpture." *Studio*, 169 (January 1965), p. 23.
"It's Art—But Will It Fly? Young Sculptor Brings Jet Age to Lincoln Center." *Life*, April 10, 1964, pp. 43–44.
Johnson, Philip. "Young Artists at the Fair and at Lincoln Center." *Art in America*, 52 (August 1964), pp. 112–27.
Judd, Donald. "In the Galleries: Lee Bontecou." *Arts Magazine*, 37 (January 1963), p. 44.
———. "Lee Bontecou." *Arts Magazine*, 39 (April 1965), pp. 16–21.
Lee. Bontecou (exhibition catalogue). Essays by Gillo Dorfles, Gérald Gassiot-Talabot, and Annette Michelson. Paris: Ileana Sonnabend Gallery, 1965.
Munro, Eleanor. *Originals: American Women Artists*. Essay on Lee Bontecou, pp. 369–81. New York: Simon and Schuster, 1979.
Ratcliff, Carter. *Lee Bontecou* (exhibition catalogue). Chicago: Museum of Contemporary Art, 1972.
Recent American Sculpture (exhibition catalogue). Article by Dore Ashton on "Lee Bontecou." New York: The Jewish Museum, 1964, pp. 12–15.

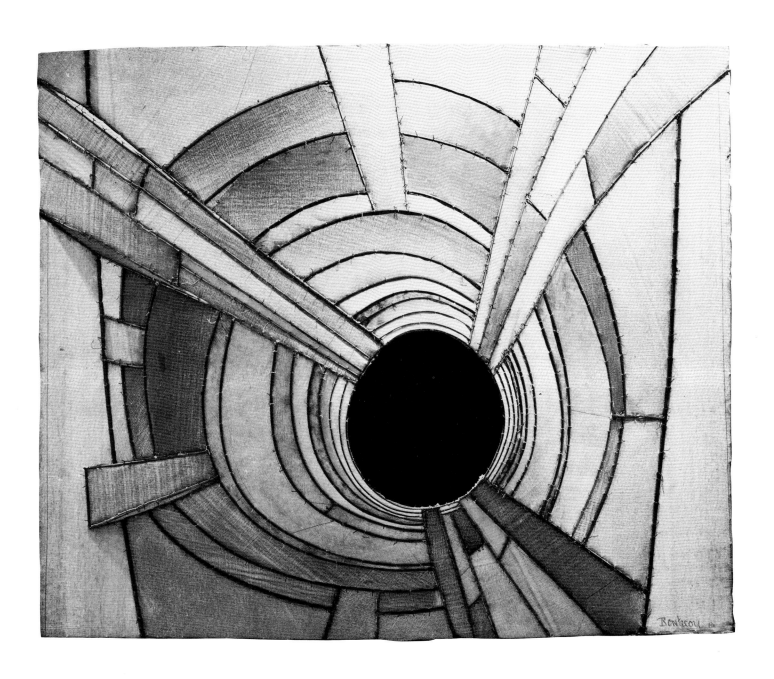

Louise Bourgeois

Born 1911

Born in Paris. Bourgeois's parents were tapestry restorers and dealers; during her youth, she assisted in the restoration process as a draftsman. She then studied mathematics at the Sorbonne, Paris (1932–35), and later switched to art, studying first at the conservative École des Beaux-Arts and then at the less restrictive Académie Ranson, Atelier Bissière, and Académie de la Grande Chaumière, while also taking courses in art history at the École du Louvre (1936–38). She came to the United States in 1938, after having married the art historian Robert Goldwater; in New York, she studied at the Art Students League with Vaclav Vytlacil.

Initially a painter, Bourgeois started making sculpture in the mid-1940s. Her first important exposure to Surrealism was in New York rather than Paris (where the prevailing influences during her student years were Cubist and Constructivist). The Surrealist preference for enigmatic and personal imagery was reflected in all her ensuing sculpture, as well as in her paintings and drawings. Attenuated, totem-like wood figures dominated her work through the 1950s.

In the early 1960s, in a radical departure from her own work as well as that of her colleagues, Bourgeois started experimenting with plaster, rubber, and cement, and with more organic forms, from which followed bronze and marble works with increasingly explicit sexual imagery. Her deepening involvement with feminist activities from the mid-1960s led to such projects as the design of sets, costumes, and posters for the Women's Interart Center in 1973. Bourgeois began traveling to quarry centers in Italy in the late sixties—first to Pietrasanta and then to Carrara—to execute work in marble. Her several major installations and environmental works of the seventies continued to explore autobiographical themes.

Bourgeois exhibited for the first time in the United States at The Brooklyn Museum's 1939 "Print Exhibition." In 1945, she had her first one-artist exhibition at the Bertha Schaefer Gallery, New York; that year marked her initial inclusion in a Whitney Museum Annual. Although her work has since been shown consistently in New York and elsewhere, it was not until the early 1970s that she began to receive wide recognition. She had a major retrospective at The Museum of Modern Art, New York, in 1982. She now lives and works in New York City.

The Whitney Museum has included Bourgeois's work in twenty-one exhibitions since the 1945 Annual, and first acquired her work in 1956, when *One and Others* (1955)—one of the two Bourgeois works owned by the Museum—entered the Permanent Collection.

Fig. 57. Louise Bourgeois, *Mortise*, 1950. Painted wood, 54 x 17 x 16″ (137.2 x 43.2 x 40.6 cm). Collection of the artist.

Bloch, Susi. "An Interview with Louise Bourgeois." *Art Journal*, 35 (Summer 1976), pp. 370–73.

Lippard, Lucy R. "Louise Bourgeois: From the Inside Out." *Artforum*, 13 (March 1975), pp. 26–33.

Miller, Lynn F., and Sally S. Swenson. "Louise Bourgeois." In *Lives and Works: Talks with Women Artists*. Metuchen, New Jersey: The Scarecrow Press, 1981, pp. 2–14.

Munro, Eleanor. *Originals: American Women Artists*. Essay on Louise Bourgeois, pp. 154–69. New York: Simon and Schuster, 1979.

Pels, Marsha. "Louise Bourgeois: An Interview." *Art International*, 23 (October 1979), pp. 46–54.

Storr, Robert. "Louise Bourgeois: Gender & Possession." *Art in America*, 71 (April 1983), pp. 128–37.

Wye, Deborah. "Louise Bourgeois." In *From Women's Eyes* (exhibition catalogue). Waltham, Massachusetts: Rose Art Museum, Brandeis University, 1977, pp. 14–19.

———. *Louise Bourgeois* (exhibition catalogue). New York: The Museum of Modern Art, 1982.

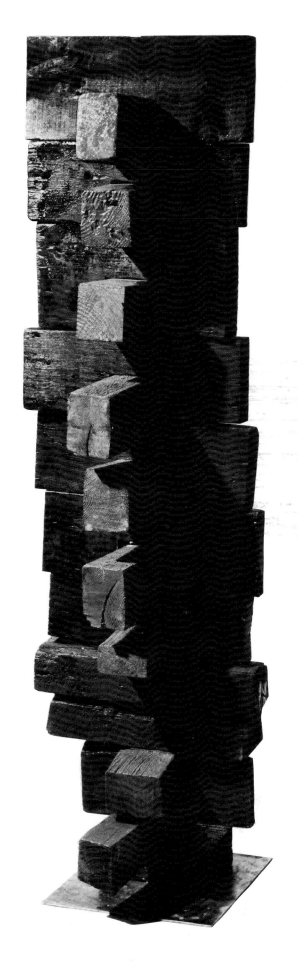

Alexander Calder

(1898–1976)

Born in Philadelphia, Pennsylvania. Both of Calder's parents and his grandfather were artists. Calder attended Stevens Institute of Technology, Hoboken, New Jersey (1915–19), taking a degree in mechanical engineering and graduating with honors in descriptive geometry. Five years later, he enrolled at the Art Students League, studying there for two years with, among others, John Sloan, George Luks, and Guy Pène du Bois. In 1925, Calder worked briefly as an illustrator for the *National Police Gazette*, covering the Ringling Brothers Circus. He went to Paris a year later and thereafter divided his time between France and the United States.

Always as much a part of the French art community as of the American, Calder was one of the first modern American sculptors to win recognition abroad. In 1926, he was hailed by the Paris avant-garde for the elevated whimsy of his wire and cloth *Circus* presentations. His first abstract sculptures with moving parts, for which Marcel Duchamp coined the term "mobiles," were made in 1950; soon afterward, Hans Arp applied the term "stabiles" to Calder's stationary abstractions. These two forms of biomorphic abstraction dominated all of Calder's succeeding work. They reflect his absorption both of Surrealist principles (especially the organic imagery of Joan Miró and Arp and the latter's interest in randomly determined compositions), and of the Cubist and Constructivist commitment to pure abstraction.

As important as the influence of French modernism was to Calder's work, French artists themselves considered his visual and mechanical ingenuity typically American. And although Calder was not the first to create moving sculpture—the Italian Futurists had made motorized works as early as 1915—his concern with the changing formal relationships between the mobiles' elements, rather than with the articulation of motion itself, was original. After 1950, Calder concentrated on metal sculpture while also designing tapestries, jewelry, and household appliances. From the late 1940s, he grew increasingly interested in monumental outdoor work. His deep response to abstract painting was reflected in his preference for linear and planar rather than fully volumetric forms, while his finely tuned sense of equilibrium and axial structure revealed his respect for traditional composition.

Calder's first one-artist New York show was in 1928. His first solo exhibition in Paris took place a year later, and his work has been exhibited extensively in both cities (and ultimately throughout the world) ever since. A 1964 retrospective at The Solomon R. Guggenheim Museum drew a record quarter-million people. The Whitney Museum presented a retrospective in 1976.

In addition to the 1976 retrospective, the Whitney Museum has presented one-artist exhibitions of Calder's tapestries (1971), of the *Circus* and related works (1972), and of selections of his work in the Permanent Collection (1981 and 1984). Since 1975, the *Circus* and the film *Calder's Circus* have been on continuous exhibition in the Museum's lobby. Calder has been represented in forty-two other exhibitions at the Museum, beginning with the 1942 Annual. The Museum owns thirteen prints, fifteen works on paper, and thirteen sculptures by Calder, the first of which to enter the Permanent Collection was *Pomegranate* (1949), acquired in 1950.

Fig. 58. Alexander Calder, *Bougainvillea*, 1947. Painted sheet metal, wire, and weights, 76 x 83″ (193 x 210.8 cm). Collection of Mr. and Mrs. Burton Tremaine.

Arnason, H. H., and Ugo Mulas. *Calder*. New York: The Viking Press, 1971.

Carandente, Giovanni. *Calder: Mobiles and Stabiles*. New York and Toronto: The New American Library, by arrangement with UNESCO, 1968.

Elsen, Albert. *Alexander Calder: A Retrospective Exhibition* (exhibition catalogue). Chicago: Museum of Contemporary Art, 1974.

Lipman, Jean, with Ruth Wolfe, ed. *Calder's Universe* (exhibition catalogue). New York: The Viking Press in cooperation with the Whitney Museum of American Art, 1976.

Messer, Thomas N. *Alexander Calder: A Retrospective Exhibition* (exhibition catalogue). New York: The Solomon R. Guggenheim Museum, 1964.

Sartre, Jean-Paul. "Existentialist on Mobilist." *Art News*, 46 (December 1947), pp. 22, 55, 56.

Staempfli, George W. "Interview with Alexander Calder." *Quadrum*, 6 (1959), pp. 9–11.

Sweeney, James Johnson. *Alexander Calder*. New York: The Museum of Modern Art, 1951.

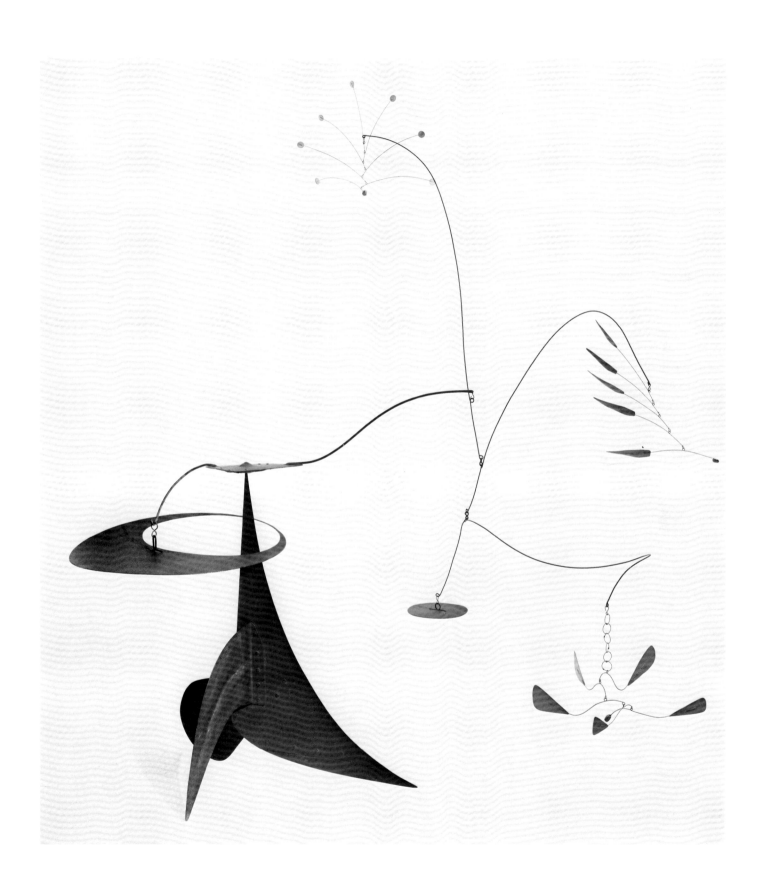

John Chamberlain

Born 1927

Born in Rochester, Indiana. Raised in Chicago, Chamberlain attended the School of The Art Institute of Chicago (1950–52) and Black Mountain College in North Carolina (1955–56).

By 1953, Chamberlain had abandoned the figurative work of his student days and turned to welded metal sculpture. In 1957, he began to use scrap metal and that year also made *Short Stop*, his first sculpture of welded automobile parts. The broad, energetic strokes of color that compose his work suggest aspects of Abstract Expressionist painting, and Chamberlain has acknowledged the influence of Franz Kline in particular. Along with George Sugarman, Chamberlain pioneered the sustained use of color in sculpture. In his employment of welded found metal, he also refers to the work of David Smith and Julio Gonzalez, as well as to the assemblage artists, many of whom exploited the original function of discarded material.

In the mid-1960s, Chamberlain temporarily turned from car parts to such materials as auto lacquer on masonite and Formica, squashed and bound foam rubber, melted Plexiglas, and crumpled industrial aluminum foil; he also experimented with film and video. Returning to automobile parts in the early 1970s, he significantly extended his ongoing series of wall reliefs, in addition to making freestanding sculpture. Like his continuous involvement with manipulated and applied color and his approximation of spontaneous gestures in welded metal, these wall reliefs reflect Chamberlain's argument against the traditional distinctions between two- and three-dimensional art. He insists, however, that the spatial presence of his sculpture is analogous to a human physical attitude, or "stance," and has referred to his work as self-portraiture.

Chamberlain's first one-artist exhibition was at the Wells Street Gallery, Chicago, in 1957. He came to New York the same year and joined the Hansa Gallery (an artists' cooperative), to which George Segal and Lucas Samaras also belonged. His first solo show in New York, at the Martha Jackson Gallery (1960), was of crushed car pieces. Since then, he has had major exhibitions at museums throughout the country, including the Cleveland Museum of Art (1967), the Contemporary Arts Center, Cincinnati (1968), The Solomon R. Guggenheim Museum, New York (1971), the Contemporary Arts Center, Houston (1975), and, most recently (1983), at the John and Mable Ringling Museum of Art, Sarasota, Florida, where he now resides. His work has also been shown abroad at the Kunsthalle Bern (1979) and the Stedelijk Van Abbemuseum, Eindhoven, Holland (1980).

The Whitney Museum, which has included Chamberlain in nineteen exhibitions, owns three sculptures and one drawing; its first acquisition was the 1963 *Untitled* in 1966.

Fig. 59. John Chamberlain, *Cord*, 1957. Steel, 17½ x 13 x 10″ (44.5 x 33 x 25.4 cm). Collection of Allan Stone.

Auping, Michael. *John Chamberlain Reliefs 1960–1982* (exhibition catalogue). Sarasota, Florida: The John and Mable Ringling Museum of Art, 1983.

Baker, Elizabeth C. "The Secret Life of John Chamberlain." *Art News*, 68 (April 1969), pp. 48–51, 63–64.

Fuchs, R. J., and Donald Judd. *Chamberlain* (exhibition catalogue). Interview by Robert Creeley. Bern, Switzerland: Kunsthalle Bern and Eindhoven, Holland: Stedelijk Van Abbemuseum, 1979.

Judd, Donald. "Chamberlain: Another View." *Art International*, 7 (January 16, 1964), pp. 38–39.

Rose, Barbara. "How to Look at Chamberlain's Sculpture." *Art International*, 7 (January 16, 1964), pp. 36–38.

———. "On Chamberlain's Interview." *Artforum*, 10 (February 1972), pp. 44–45.

Tuchman, Phyllis. "An Interview with John Chamberlain." *Artforum*, 10 (February 1972), pp. 38–43.

Waldman, Diane. *John Chamberlain: A Retrospective Exhibition* (exhibition catalogue). New York: The Solomon R. Guggenheim Museum, 1971.

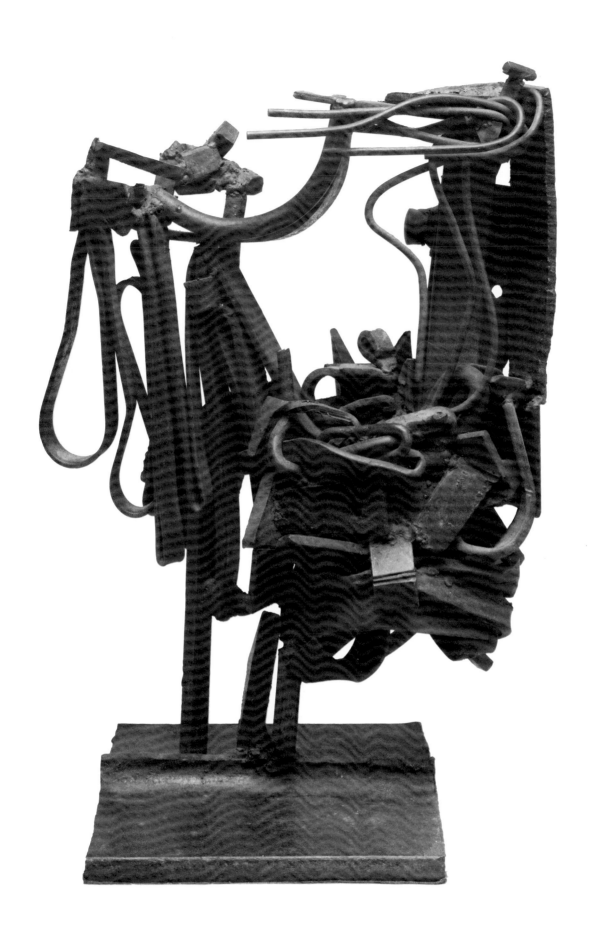

Mark di Suvero

Born 1933

Born in Shanghai, China, to Italian parents. Di Suvero's family moved in 1941 to San Francisco, where he attended San Francisco City College; he later went to the University of California at Santa Barbara and Berkeley (B.A., philosophy, 1957). At the same time, he studied sculpture, first with Robert Thomas at Santa Barbara and then with Stefan Novak at Berkeley. Soon after graduation, he moved to New York.

Di Suvero's work has always been characterized as gestural, initially as a way of relating it to painting, and later to describe its actual movement through space. The early wood assemblages were composed of rough, weathered planks and beams in bold expressionist strokes suggestive of Franz Kline and Willem de Kooning. In 1960, he began making small welded metal pieces, and in 1961–62 he combined wood and steel. Around 1964, he introduced moving parts to his sculpture and, by the end of the decade, he was working on a much larger scale, using bolted and wired I-beams. The massive outdoor work di Suvero created in Europe in the 1970s was frequently based on such regular geometric forms as the tetrahedron and had a reductive, industrial character. Nevertheless, these pieces confirmed his basically romantic sensibility. Like the smaller pieces made at the same time (and work on both scales since), they employ sweeping forms, moving parts, unexpected opportunities for viewer involvement, and precarious balance —all expressions of physical and formal adventure.

Di Suvero's first one-artist show, at Richard Bellamy's Green Gallery, New York, opened in October 1960, seven months after a nearly fatal accident. He was soon (and unexpectedly) able, however, to return to sculpture, and in 1962 was a co-founder of the cooperative Park Place Gallery, New York, where he had a one-artist show in 1966. He returned to California in 1963, creating his first large outdoor sculpture there during the next two years. In late 1971, di Suvero moved to Europe in protest against the American military involvement in Southeast Asia. He lived and worked during 1972 first in Holland, then in Germany, and he spent 1973–75 in France. In all three countries, he had major museum exhibitions. Di Suvero returned to the United States in 1975 for a major one-artist exhibition at the Whitney Museum, which also presented selections of his large-scale outdoor pieces in all five boroughs. He lives and works in New York.

In addition to presenting the 1975 retrospective, the Whitney Museum has included di Suvero's work in thirteen group shows and owns four sculptures and one print. The first work to enter the Museum's Permanent Collection was *New York Dawn (for Lorca)*, 1965, acquired in 1966.

Fig. 60. Mark di Suvero, *Che Faro Senza Eurydice*, 1959. Wood, rope, and nails, 84 x 104 x 91" (213 x 264 x 231 cm). Private collection.

Geist, Sidney. "A New Sculptor: Mark di Suvero." *Arts Magazine*, 35 (December 1960), pp. 40–43.
Hess, Thomas. "Mark Comes in Like a Lion." *New York Magazine*, December 15, 1975, pp. 94–98.
Hughes, Robert. "Truth Amid Steel Elephants." *Time*, August 2, 1971, pp. 48–49.
Kozloff, Max. "Mark di Suvero: Leviathan." *Artforum*, 5 (Summer 1967), pp. 41–46.
Kramer, Hilton. "Di Suvero: Sculpture of Whitmanesque Scale." *The New York Times*, January 30, 1966, p. 25.
Monte, James K. *Mark di Suvero* (exhibition catalogue). New York: Whitney Museum of American Art, 1975.
Ratcliff, Carter. "Mark di Suvero." *Artforum*, 11 (November 1972), pp. 34–42.
Rosenstein, Harris. "Di Suvero: The Pressures of Reality." *Art News*, 65 (February 1967), pp. 36–39, 63–65.

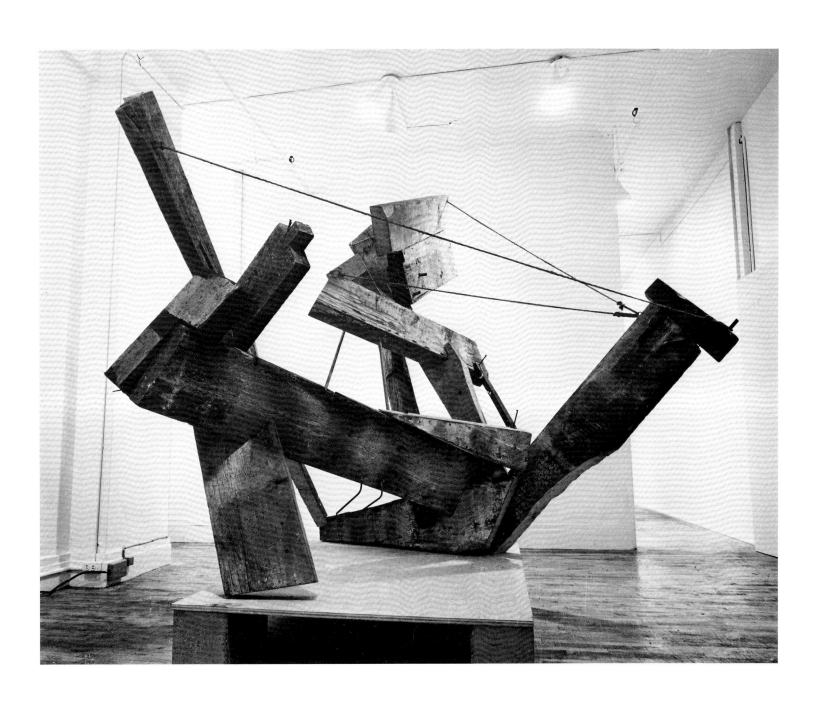

Herbert Ferber

Born 1906

Born Herbert Ferber Silvers in New York City, the son of a typesetter and trade-school printing teacher. Ferber attended City College of New York (1923–26), majoring in science and auditing classes in literature, philosophy, and art history. In 1926, he transferred to Columbia University (B.S., 1927). He studied nights at the Beaux-Arts Institute of Design (1927–30), while enrolled in dental school. After teaching at the Columbia University Dental School upon graduation, and then establishing a part-time practice in 1934, Ferber continued his art education, taking classes briefly at the National Academy of Design, New York. He also studied social science and philosophy and involved himself in the political issues that dominated the decade. In 1936, he joined the socialist John Reed Club, three years after having participated in a polemical exhibition at the club's gallery entitled "Paintings, Sculpture, Drawings, Prints on the Theme Hunger, Fascism, War." In 1935, on the first of several trips to Central America, he purchased Pre-Columbian sculpture in Mexico. In France in 1938, he was particularly interested in the Romanesque sculpture at Moissac, Souillac, and Carcassone.

Ferber started his artistic career as a painter and graphic artist, but took up carved wood sculpture in 1931 under the influence of William Zorach, then the foremost exponent of the direct-carving process. Ferber worked primarily in wood and occasionally in stone and bronze for the next fifteen years, with references to African, Pre-Columbian, and Romanesque sources. His carved wood and, increasingly, cast metal work of the late 1930s and early 1940s ranged from stylized figuration to organic abstraction, in somewhat ponderous forms that revealed Henry Moore's influence. In 1945, he turned from casting to welding, which allowed for a far lighter and more open vocabulary. At this point, he abandoned all but the most oblique figurative references, and by the early 1950s had developed a fluid, almost calligraphic gestural style. In 1954, he made his first roofed sculptures—cage-like structures which effected a resolution of the geometric and the biomorphic. By their analogy to the viewer's spatial context, these pieces anticipated Ferber's ground-breaking environmental works. *A Sculpture to Create an Environment*, one of the earliest examples of a large-scale, indoor installation, was commissioned by the Whitney Museum and shown there in 1961.

Ferber had his first one-artist show at the Midtown Galleries, New York, in 1937. After World War II, he joined the Betty Parsons Gallery and showed there and at the Kootz Gallery through the 1950s. He was commissioned in 1951, along with the painters Adolph Gottlieb and Robert Motherwell, to create a work for B'nai Israel Congregation in Millburn, New Jersey, the first of several architectural commissions. Ferber's first retrospective was held at Bennington College, Vermont, in 1958. In 1962, a retrospective was organized by the Walker Art Center, Minneapolis, which traveled throughout the country and was seen at the Whitney Museum. In 1981, another retrospective was held at The Museum of Fine Arts, Houston.

Ferber has been included in twenty-three Whitney Museum Annuals, twelve other group exhibitions at the Museum, and is represented in the Permanent Collection by five sculptures and one drawing. His work first entered the collection in 1951 (*The Flame*, 1949).

Fig. 61. Herbert Ferber, *Sun Wheel*, 1956. Brass, copper, and stainless steel, 56¼ x 29 x 19″ (142.9 x 73.7 x 48.3 cm). Whitney Museum of American Art, New York; Purchase 56.18.

Agee, William C. *Herbert Ferber: Sculpture, Painting, Drawing: 1945–1980* (exhibition catalogue). Houston: The Museum of Fine Arts, 1983.

Andersen, Wayne V. *The Sculpture of Herbert Ferber* (exhibition catalogue). Minneapolis: Walker Art Center, 1962.

Balken, Debra Bricker, and Phyllis Tuchman. *Herbert Ferber: Sculpture & Drawings 1932–1983* (exhibition catalogue). Pittsfield, Massachusetts: The Berkshire Museum, 1984.

Faison, S. Lane, Jr. "The Sculpture of Herbert Ferber." *College Art Bulletin*, 17 (Summer 1958), pp. 363–71.

Ferber, Herbert. "The Ides of Art: The Attitudes of 10 Artists on Their Art and Contemporaneousness." *The Tiger's Eye*, no. 2 (December 1947), p. 44.

———. "The Ides of Art: 14 Sculptors Write." *The Tiger's Eye*, no. 4 (June 1948), pp. 75–76, 103.

———. "On Sculpture." *Art in America*, 42 (December 1954), pp. 262–65, 307–08.

———. "Sculpture as Environment." *Art International*, 4 (May 1, 1960), p. 70.

Goldwater, Robert. *Herbert Ferber: First Retrospective Exhibition* (exhibition catalogue). Bennington, Vermont: Bennington College, 1958.

Goodnough, Robert. "Ferber Makes a Sculpture." *Art News*, 51 (November 1952), pp. 40–43.

Goossen, Eugene C. *Herbert Ferber*. New York: Abbeville Press, 1981.

———, Robert Goldwater, and Irving H. Sandler. *Three American Sculptors: Ferber, Hare, Lassaw*. New York: Grove Press, 1959.

Miller, Dorothy C., ed. *15 Americans* (exhibition catalogue). Statement by Ferber. New York: The Museum of Modern Art, 1952.

Newman, Barnett B. *Herbert Ferber* (exhibition catalogue). New York: Betty Parsons Gallery, 1947.

Tuchman, Phyllis. "An Interview with Herbert Ferber." *Artforum*, 9 (April 1971), pp. 52–57.

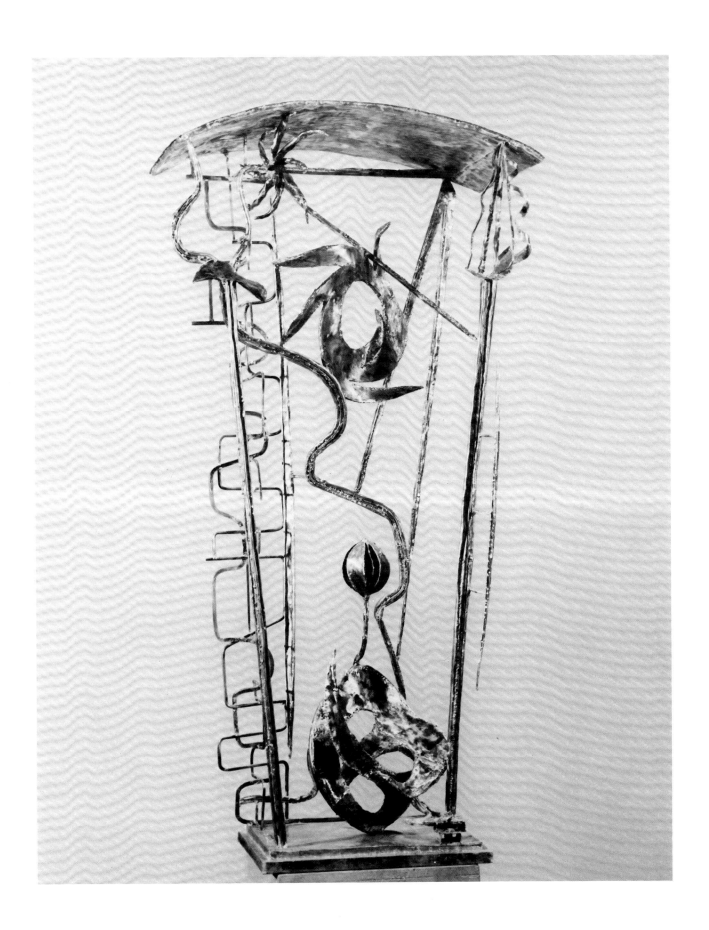

Raoul Hague

Born 1905

Born Raoul Heukelekian to Armenian parents in Constantinople. At the age of sixteen, he emigrated by himself to the United States, studying at Iowa State College. He moved to Chicago two years later and enrolled at the School of The Art Institute. In 1925, he went to New York City, where he carved in stone under William Zorach at the Art Students League and also attended classes at the Beaux-Arts Institute of Design. At this time, he formed friendships with fellow Armenian artist Arshile Gorky and with Willem de Kooning and John Flannagan. Between 1935 and 1939, Hague was employed by the WPA. He served in the army during World War II and went to Europe on the G.I. Bill in 1950. He stayed for some time in London, attending art history courses at the Courtauld Institute, and then traveled to France, Italy, Greece, and Egypt.

Throughout his career, Hague has maintained a commitment to the principles of direct carving promoted by Zorach and Flannagan. The heavy rounded forms of his figurative stone sculpture of the 1930s, in which the material's tactile qualities were emphasized, also revealed the influence of the Mexican muralist Diego Rivera —particularly of his simple, powerful, narrative style. The sculpture of Constantin Brancusi as well as of the African and Pre-Columbian sculpture then being widely discussed also contributed to Hague's reductive, though still evocative, organic abstraction.

In 1941, Hague left New York City and its art community for the upstate town of Woodstock. His sculpture since the mid-1940s, when he began to work exclusively in wood, reflects a clear, unencumbered and unyielding vision. Spending as long as five months on a single sculpture, he works, as he describes it, in tandem with the specific strengths of each chosen piece of wood. He does not preconceive his forms, nor does he consider them reflections of unconscious motives; rather, they are expressions of the physical and metaphorical possibilities inherent in the material itself. Hague's work was much talked about in the mid-1950s, when he was included in the "12 Americans" exhibition at The Museum of Modern Art, New York, and he has been a quietly persuasive influence on the art scene ever since.

Hague has been represented in group exhibitions from 1952 on, when he was included in The Museum of Modern Art's show "American Sources of Modern Art," an exhibition linking Pre-Columbian and twentieth-century art. Since that time, his work has appeared in numerous shows at The Museum of Modern Art, the Whitney Museum, and elsewhere. His first one-artist exhibition, however, did not take place until 1962 at the Egan Gallery, New York. In 1964, The Washington Gallery of Modern Art, Washington, D.C., presented a retrospective of Hague's sculpture, as did the Arts Club of Chicago in 1983. He lives and works in Woodstock, New York.

The Whitney Museum, which has represented Hague in sixteen exhibitions between 1946 and 1981, owns two of his works, the first of which to enter the Permanent Collection was *Sawkill Walnut* (1955), acquired in 1957.

Fig. 62. Raoul Hague, *Mount Marion Walnut*, 1952–54. Walnut, 32½ x 36¾ x 26″ (82.6 x 93.3 x 66 cm). Albright-Knox Art Gallery, Buffalo; Gift of Seymour H. Knox.

Giannini, Paula. "Raoul Hague: An Interview." *Art International*, 24 (August-September 1981), pp. 8–25.
Hess, Thomas B. "Introducing the Sculpture of Raoul Hague." *Art News*, 53 (January 1955), pp. 19–21.
Miller, Dorothy C., ed. *12 Americans* (exhibition catalogue). Statement by Thomas B. Hess. New York: The Museum of Modern Art, 1956.
Nordlund, Gerald. *Raoul Hague* (exhibition catalogue). Introduction by Dorothy C. Miller. Washington, D.C.: The Washington Gallery of Modern Art, 1964.
S[andler], I[rving] H. "Hague: The Wood of Dreams." *Art News*, 61 (November 1962), pp. 38–39.
Steinberg, Leo. "Month in Review: 'Twelve Americans,' Part II." *Arts*, 30 (July 1956), pp. 25–26.

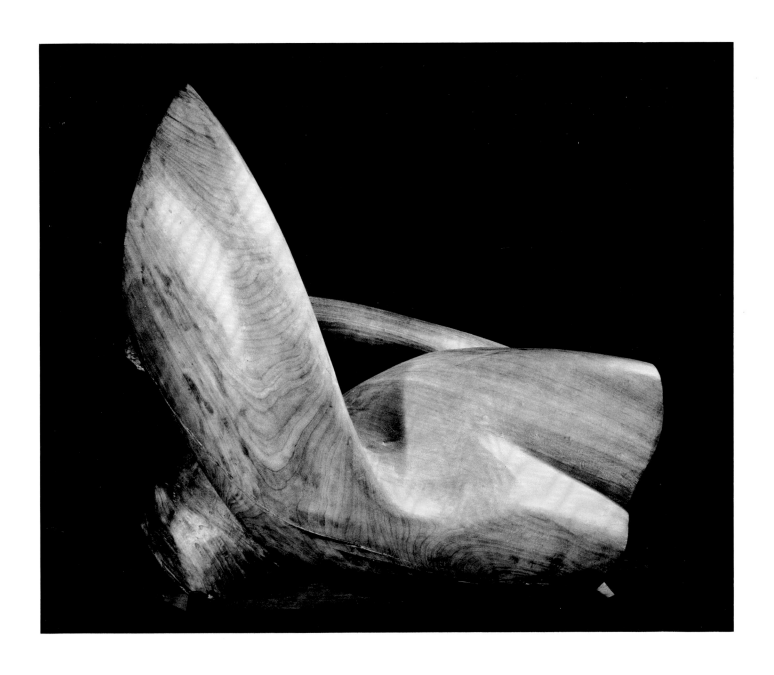

David Hare

Born 1917

Born in New York City. Hare never formally studied art, although his mother was involved in the nascent New York avant-garde art community early in the century and was a backer of the 1913 Armory Show. At schools in Arizona, Colorado, and New York, he majored in chemistry and biology in preparation for a career in medicine. After graduation, Hare became a commercial photographer, documenting surgical operations and working as a portraitist. Following experiments in 1941 with a photographic technique called "heatage," developed by the French Surrealist Raoul Ubac, Hare became acquainted with the expatriate Surrealists in New York. From 1942 to 1944, he edited the Surrealist review *VVV*, assisted by André Breton, Marcel Duchamp and, later, Max Ernst. In 1948, he helped found, with several Abstract Expressionists, the short-lived Subjects of the Artist school and was a charter member of the more enduring Club in 1949—both organizations were important forums for the exchange of ideas about contemporary art in New York. Hare lived in Paris for several years during the 1950s and now lives and works in New York.

Perhaps more closely involved with the French Surrealists than any other American artist, Hare has remained committed to their exploration of automatism, mythological subjects, and imagery associated with the unconscious. His earliest sculpture, produced in the mid-1940s, was composed of plaster and wire forms suspended from the ceiling and suggested Calder's influence. His succeeding work, in cast bronze and, from around 1951, welded metal, continued to develop a quasi-figurative, richly symbolic vocabulary. Less interested in the intrinsic qualities of materials or process than in the range of expressions they permit, Hare has several times switched media, turning to painting in the mid-1960s and resuming sculpture in the early seventies.

Hare's first one-artist show, in 1939 at the Webster Gallery, New York, presented photographs of well-known political and social figures. In 1940, he had a solo photography show at the Julien Levy Gallery, New York, and produced a photographic portfolio of Indians from Arizona and New Mexico for the American Museum of Natural History, New York. His photographs were included in the 1942 "First Papers of Surrealism" exhibition at the Whitelaw Reid Mansion, New York. He exhibited sculpture for the first time at Peggy Guggenheim's Art of This Century Gallery in 1944 and showed there again in 1945 and 1946. For the next thirteen years, he exhibited regularly at the Kootz Gallery, New York. The Philadelphia College of Art presented a retrospective of his work in 1965, and in 1977, The Solomon R. Guggenheim Museum organized an exhibition of his Cronus series of paintings. The Grey Art Gallery and Study Center, New York University, presented a two-artist show, featuring Hare and Frederick Kiesler, in 1982.

The Whitney Museum included Hare in its 1948 Annual and thereafter in twenty-four group shows. The Museum owns one collage and two sculptures by Hare, the first of which to enter the Permanent Collection was *Juggler* (1950–51), acquired in 1951.

Fig. 63. David Hare, *The Dinner Table*, 1950. Welded steel, 90 x 62½ x 47½" (228.6 x 158.8 x 120.7 cm). Grey Art Gallery and Study Center, New York University Art Collection; Gift of John Goodwin.

Ashton, Dore. "Philosopher or Dog? A Consideration of David Hare." *Arts Magazine*, 50 (May 1976), pp. 80–81.

Cameron, Daniel. "David Hare." *Grey Art Gallery Bulletin*, 4 (Summer 1982), unpaged.

Goldwater, Robert. "David Hare." *Art in America*, 44 (Winter 1956–57), pp. 18–20, 61.

Goodnough, Robert. "David Hare Makes a Sculpture." *Art News*, 55 (March 1956), pp. 46–59.

Goossen, Eugene C., Robert Goldwater, and Irving H. Sandler. *Three American Sculptors: Ferber, Hare, Lassaw*. New York: Grove Press, 1959.

Hare, David. "The Spaces of the Mind." *Magazine of Art*, 43 (February 1950), pp. 48–53.

———. "The Myth of Originality in Contemporary Art." *Art Journal*, 24 (Winter 1964–65), pp. 139–42.

———. "The Artist Just Runs Like Hell to Keep Ahead of His Public." *Art in America*, 55 (January-February 1967), p. 52.

Miller, Dorothy C., ed. *14 Americans* (exhibition catalogue). New York: The Museum of Modern Art, 1946.

Rosenberg, Harold. "The Art World: American Surrealist." *The New Yorker*, October 24, 1977, pp. 155–58.

Frederick Kiesler

(1896–1965)

Born in Vienna. In 1914, after studying architecture in Vienna, Kiesler was drafted into the army and served three years, partly at the front. In 1920, he worked in Vienna with Adolf Loos on the city's first slum clearance and rehousing projects. Three years later, Kiesler designed the first version of the *Endless House*—a flexible structure derived from organic forms—as a theater; also in 1923, he joined the de Stijl group and designed two other experimental theater productions, in one of which he incorporated motion pictures as backdrops. In 1924, he designed Vienna's International Exhibition of New Theater Technique and, at the 1925 Paris World's Fair, he created *City in Space* for the Austrian Theater exhibition.

Kiesler came to New York in 1926 at the invitation of the Theatre Guild to create an exhibition of international theater technique, demonstrating radical developments in scenography and stage design, for the opening of Steinway Hall. He became an associate at the Harvey Wiley Corbett architectural firm (1926–28) and in 1930 designed the Film Guild Cinema (now the Eighth Street Cinema), with the first built-in "Screen-O-Scope" for enlarged screen projection. From 1933 to 1957, he was Director of Scenic Design at the Juilliard School of Music and, between 1936 and 1942, he was also Director of the Bauhaus-oriented Design Laboratory at the Columbia University School of Architecture.

During the late 1930s and early 1940s, Kiesler became associated with the Surrealists, and in 1942 he created a startling installation—paintings hung on baseball bats projecting from curved walls—for the Surrealist exhibition with which Peggy Guggenheim opened her Art of This Century Gallery. In 1947, he designed the International Surrealist Exhibition at the Galerie Maeght in Paris, directed by André Breton and Marcel Duchamp, for which he produced his first sculpture, *Totem of Religions*. Kiesler showed his environmental wood construction *Galaxy* in 1952 at The Museum of Modern Art, New York. This work developed the principles of organic, fluid spatial organization first articulated in the *Endless House* (1949–59). He continued to pursue both architecture and sculpture, forming the architectural firm of Kiesler and Bartos in 1957, and exhibiting sculpture at several New York galleries. Kiesler was given a one-artist exhibition at The Solomon R. Guggenheim Museum in 1964 and another show with David Hare at New York University's Grey Art Gallery and Study Center in 1982. Later architectural commissions included a sanctuary for the Dead Sea Scrolls at Hebrew University, Jerusalem (*Shrine of the Book*, 1959, in association with Armand Bartos), and the Ulman Research Center at the Albert Einstein Medical Center, New York (also in 1959 with Bartos).

In Kiesler's many written statements and two books, he outlined remarkably advanced ideas on structure (promoting "floating," cantilevered architecture in the 1920s), alternative energy applications (advocating the use of solar energy as a cost-cutting device in the mid-1960s), and "continuous" design. An artist of many talents, he incorporated his notions of "endless" space in his sculpture and environmental installations as well as in his architecture and pioneered the integration of these disciplines with the performing arts.

The Whitney Museum included Kiesler in its 1956 Annual and in four subsequent group exhibitions. The Museum owns one Kiesler sculpture, *Landscape: The Savior Has Risen* (1964), acquired in 1966; another work is a promised gift.

Fig. 64. Frederick Kiesler, *The Arch: A Sculpted Rainbow to Walk Through*, 1959–65. Bronze and aluminum, 118 x 134 x 36″ (229.7 x 340.4 x 91.4 cm). Collection of Lillian Kiesler.

Barr, Alfred H., Jr. "Kiesler's Galaxy." *Harper's Bazaar*, 85 (April 1952), pp. 142–43.

de Kooning, Elaine. "Dickinson and Kiesler." *Art News*, 51 (April 1952), pp. 20–23, 66–67.

Goldberg, RoseLee. "Frederick Kiesler, Endless Love." *Flash Art*, no. 102 (March-April 1981), pp. 37–39.

Goodman, Cynthia. *Frederick Kiesler (1890–1965): Visionary Architecture, Drawings and Models, Galaxies and Paintings, Sculpture* (exhibition catalogue). New York: André Emmerich Gallery, 1979.

H[ess], T[homas] B. "Reviews and Previews." *Art News*, 53 (October 1954), p. 51.

Kiesler, Frederick. "On Correalism and Biotechnique: A Definition and Test of a New Approach to Building Design." *Architectural Record*, 86 (September 1939), pp. 60–75.

———. "The Art of Architecture for Art." *Art News*, 56 (October 1957), pp. 38–43, 50–54.

———. "Design in Continuity." *Architectural Forum*, 107 (October 1957), pp. 126–31.

———. "Hazard and the Endless House." *Art News*, 59 (November 1960), pp. 46–48.

———. "Second Manifesto of Correalism." *Art International*, 9 (March 1965), pp. 16–23.

———. *Inside the Endless House*. New York: Simon and Schuster, 1966.

———. "The Future: Notes on Architecture as Sculpture." *Art in America*, 54 (May-June 1966), pp. 57–68.

Levin, Kim. "Kiesler and Mondrian, Art into Life." *Art News*, 63 (May 1964), pp. 38–41, 49–50.

Miller, Dorothy C., ed. *15 Americans* (exhibition catalogue). New York: The Museum of Modern Art, 1952.

The Solomon R. Guggenheim Museum. *Frederick Kiesler: Environmental Sculpture* (exhibition catalogue). Essay by the artist. New York: The Solomon R. Guggenheim Foundation, 1964.

Gabriel Kohn

(1910–1975)

Born in Philadelphia. Kohn, whose father was a photo-engraver, moved with his family to New York in 1915. He studied at Cooper Union (1929) and at the Beaux-Arts Institute of Design (1930–34); during this time he also served as an assistant to the architectural sculptor Hermon Atkins MacNeil. Kohn moved to California in 1935, working as a set builder for Paramount Pictures in Hollywood (1935–42), while continuing to sculpt. From 1942 to 1945, he was a camouflage designer for the Army Air Corps. After a brief stay in Los Angeles at the end of World War II, he went to Europe, studying for a year in Paris with Ossip Zadkine and then traveling widely, living briefly in Nice, Rome, and Alba, France. He returned to America in 1952 and taught for a year at the Cranbrook Academy of Art, Bloomfield Hills, Michigan. Kohn moved to New York in 1954, then to Florida (1961), and finally back to Los Angeles (1965), where a serious car accident in 1968 significantly curtailed his ability to work.

Kohn's early figurative work in terracotta, plaster, and bronze reveals, in its architectonic quality, his appreciation of the blocky, simplified forms preferred by Jacques Lipchitz and Alexander Archipenko. During Kohn's stylistically diverse European period, exposure to Romanesque and late nineteenth-century French sculpture also had an impact on his art. On his return to New York from Michigan, he began to work exclusively in wood, at first carving and then constructing assemblages. By the late 1950s, he had developed his characteristic style, which reconciled the intuitive impulses of Abstract Expressionism with the geometries of Constructivism. The wood sculpture from 1956 on was created in an improvisational, additive process that employed such carpentry techniques as doweling, laminating, and joining. Kohn believed architecture to be the "grandest form of sculpture," and his work, in which skewed, dramatically asymmetrical volumes recur, demonstrates his fine sense of spatial organization and balance.

Kohn's first one-artist show took place in Rome in 1948. He had a one-artist show in New York ten years later and thereafter exhibited intermittently in this country and in Europe. The John and Mable Ringling Museum of Art, Sarasota, Florida, presented a survey of Kohn's work in 1964, as did the Newport Harbor Art Museum, Newport Beach, California, in 1971. A retrospective was held in 1977 at The Corcoran Gallery of Art, Washington, D.C.

Kohn's work was included in the 1953 Whitney Museum Annual and in nine other group exhibitions. The Museum owns one drawing by Kohn, and one sculpture, *Square Root* (1958), acquired in 1960.

Fig. 65. Gabriel Kohn, *Guest in the House*, 1958. Wood, 50 x 21 x 11½ " (127 x 53.3 x 29.2 cm). Private collection.

Ashton, Dore. "Gabriel Kohn." *Cimaise*, 7 (September-November 1959), pp. 58–65.

Garver, Thomas H. *Wood: The Sculpture of Gabriel Kohn* (exhibition catalogue). Newport Beach, California: Newport Harbor Art Museum, 1971.

Kramer, Hilton. "Four Tributes: Gabriel Kohn, 1910–1975." *Art in America*, 64 (January-February 1976), p. 21.

Livingston, Jane. *Gabriel Kohn, 1910–1975* (exhibition catalogue). Washington, D.C.: The Corcoran Gallery of Art, 1977.

Miller, Dorothy C., ed. *Americans 1963* (exhibition catalogue). Statement on Kohn by William Rubin. New York: The Museum of Modern Art, 1963.

Petersen, Valerie. "Gabriel Kohn Makes a Sculpture." *Art News*, 60 (October 1961), pp. 48–51, 66, 67.

Sandler, Irving H. "American Construction Sculpture." *Evergreen Review*, 2 (Spring 1959), pp. 136–46.

Ibram Lassaw

Born 1913

Born in Alexandria, Egypt, to Russian parents. Lassaw moved in his early child-hood to Marseilles, Naples, and Constantinople, finally emigrating with his family to New York in 1921. In 1927, he enrolled at the newly created Clay Club (now the Sculpture Center), studying modeling, casting, and direct-carving techniques there until 1932. In the early 1930s, he also attended the Beaux-Arts Institute of Design and City College of New York. He worked for various federal arts programs from 1933 to 1942. In 1936, he was one of the founders of the American Abstract Artists organization, where he later served as president (1946–49). In 1950, he hosted the first meeting of the Club, one of the most important forums of Abstract Expressionism, at which dozens of artists and scholars spoke and exchanged ideas during the next decade. Lassaw has taught periodically at major American uni-versities since 1950. He currently lives and works in The Springs, Long Island.

Lassaw's wide-ranging intellectual interests have influenced his work through-out his career. Having absorbed by the age of twenty the theories not only of the Bauhaus (particularly as put forth by László Moholy-Nagy) but also of Buckminster Fuller, Lassaw went on to read widely in the physical sciences, and studied Zen Buddhism (under Daisetz Suzuki at Columbia University, 1953–55). His belief that reality is a process, and that the process can be identified with a universal religious principle, is expressed in his understanding of the sculptural object as part of a physical-spiritual continuum. Lassaw was creating abstract sculpture, mainly bio-morphic plaster forms, by 1933. He then experimented with a number of materials, including rubber, sheet steel, and brazed iron with wood (late 1930s); Lucite, with and without stainless steel (early 1940s); and copper-covered wire (c. 1950). In 1951, he turned to oxyacetylene welding, applying a process learned in tech-nical school while serving in the army during World War II. Using welding rods in a variety of alloys, he obtained a color range, texture, and delicacy that charac-terize his mature sculpture. In this work, freely drawn three-dimensional grids and abstracted organic figures are rendered by a gestural line which composes space rather than displaces it.

Following representation in a 1950 group show at the Salon des Réalités in Paris, Lassaw had his first one-artist show in 1951 at the Kootz Gallery, New York, where he exhibited regularly between 1951 and 1965. He was included in the 1954 Venice Biennale, Documenta II in Kassel (1959), and the Pittsburgh International (1960–61). In 1973, a retrospective was held at the Heckscher Museum, Hunting-ton, New York, and the Zabriskie Gallery, New York, surveyed ten years of his work in 1977. Lassaw has also completed large-scale indoor and outdoor commis-sions for several synagogues, a church, and private homes in the Northeast.

Lassaw's work was first included in a Whitney Museum Annual in 1936 and has been shown in fifteen subsequent Annuals and fourteen other group exhibitions. The Whitney Museum owns three works on paper and two sculptures by Lassaw, the first of which to enter the Permanent Collection was *Procession* (1955–56), acquired in 1956.

Fig. 66. Ibram Lassaw, *Kwannon*, 1952. Bronze, 72 x 43 x 27″ (182.9 x 109.2 x 68.6 cm). The Museum of Modern Art, New York; Katherine Cornell Fund.

Campbell, Lawrence. "Lassaw Makes a Sculp-ture." *Art News*, 53 (March 1954), pp. 24–27, 66–67.

Ibram Lassaw (exhibition catalogue). State-ments by the artist. Durham, North Carolina: Duke University, 1963.

Goossen, Eugene C., Robert Goldwater, and Irving H. Sandler. *Three American Sculptors: Ferber, Hare, Lassaw*. New York: Grove Press, 1959.

Heckscher Museum. *Ibram Lassaw* (exhibition catalogue). Excerpts from "Perspectives and Reflections of a Sculptor: A Memoir" by the artist. Huntington, New York, 1973.

Hunter, Sam. *The Sculpture of Ibram Lassaw* (exhibition catalogue). Detroit: Gertrude Kasle Gallery, 1968.

Lassaw, Ibram. "Color for Sculpture." *Art in America*, 49 (1961), pp. 48–49.

———. "Perspectives and Reflections of a Sculptor: A Memoir." *Leonardo*, 1 (1968), pp. 351–61.

Sawin, Martica. "Ibram Lassaw." *Arts*, 30 (December 1955), pp. 2–6.

Wolfe, Judith. *Ibram Lassaw: Detwiller Visiting Artist* (exhibition catalogue). Easton, Pennsyl-vania: The Gallery, Morris R. Williams Center for the Arts, Lafayette College, 1983.

Michael Lekakis

Born 1907

Born in New York City. As a youth, Lekakis prepared floral arrangements and decorations in his father's wholesale flower business. Except for a brief enrollment at the Art Students League, he had no formal art education. During World War II, he developed and taught aerial camouflage design. In addition to being a sculptor, Lekakis is a painter, printmaker, and poet and his work has been acclaimed and analyzed as much by philosophers and poets as by artists and critics; Ezra Pound and E. E. Cummings have been among his close friends. He has traveled widely, especially in Greece, and has remained deeply involved with New York's Greek community, in which he was raised. He has also studied classical Greek philosophy and mythology as well as Eastern philosophy and religion.

Lekakis' work, because of its organicism—its tendency to eccentric natural shapes—has been compared to that of Constantin Brancusi and Hans Arp. Unlike those two sculptors, however, Lekakis is primarily interested in collaborating with his material to reveal the generative forces of nature. The forms he has used fairly consistently through his career include columns, spheroid clusters, and slender linear elements developed from found configurations of tree roots, branches, and trunks. He has worked in plaster and bronze casting but prefers wood for its expression of the processes of biological growth. Occasionally, he has groomed small stands of trees for series of works, a practice not unlike that of the traditional Japanese *bonsai*, in which the growth patterns of trees are manipulated for aesthetic effect. Lekakis has also appropriated another venerable tradition—"entasis." In classical Greek architecture, entasis was an optical strategy—the slight swelling of a column—designed to achieve a more pleasing sense of vertical extension. Lekakis understands it as a more general principle of natural dynamism and applies it freely to produce the slightly swollen, seemingly expanding forms that characterize his work.

Although Lekakis began drawing and carving in the 1920s and became associated early on with the avant-garde art community in New York, he has had relatively few gallery shows. His first one-artist exhibition was held at the Artist's Gallery, New York, in 1941; another took place twenty years later at the Howard Wise Gallery, New York. He now lives and works in Southampton, Long Island.

The Whitney Museum, in addition to presenting a one-artist show of Lekakis' work (1973–74), has included him in eleven Annuals from 1948 on and in four other group shows. *Sympan* (1960) entered the Permanent Collection in 1961.

Fig. 67. Michael Lekakis, *Keraia*, 1958. Cherry, with yellow pine base, 83 x 55 x 35″ (210.8 x 139.7 x 88.9 cm). Philadelphia Museum of Art; Gift of Clorinda and Joseph Margolis.

Colt, Priscilla. *Sculpture and Drawings by Michael Lekakis. Dayton Art Institute Bulletin*, 26 (January 1968). Special exhibition issue.
Granitsas, Spyridon. "Oracles and Visions in Wood." *Pictures from Greece*, no. 74 (March 1962), pp. 44–45.
Howard, Richard. "On Michael Lekakis." *Shenandoah*, 26 (Spring 1975), pp. 146–55.
Margolis, Joseph. "Michael Lekakis and the 'Heuristics' of Creation." *Main Currents in Modern Thought*, 31 (March-April 1975), pp. 107–14.
————. *Michael Lekakis: Five Decades* (exhibition catalogue). New York: Kouros Gallery, 1983.
————. "Michael Lekakis." *Arts Magazine*, 58 (November 1983), p. 8.
Rosenberg, Harold. "The Art Galleries, Black and Pistachio." *The New Yorker*, June 15, 1963, pp. 84–98.
T[illim], S[idney]. "Month in Review: Michael Lekakis." *Arts Magazine*, 36 (December 1961), p. 51.

Richard Lippold

Born 1915

Born in Milwaukee. Lippold attended the University of Chicago and the School of The Art Institute of Chicago (1933–37), graduating with a degree in industrial design. He worked in this field through 1941, first for the Cherry-Burrell Corporation, manufacturers of equipment for the dairy industry, and then in his own firm. In 1940, he taught design at the Layton School of Art in Milwaukee and, from 1941 to 1944, at the University of Michigan at Ann Arbor. He began to make sculpture in 1942 and moved to New York in 1944. He now lives and works in Glen Cove, Long Island.

Lippold's first sculptures were intuitively determined wire and mixed media abstractions. He continued to use wire and thin metal elements, but in the late 1940s became intrigued by more regular, angular geometries and modular compositions. Although the titles of Lippold's works often refer to classical mythology or primordial life, their precise constructions suggest a comparison with the visual models used in atomic physics. The first five works in Lippold's series of Variations on a Sphere, begun in 1947, were dedicated to composer John Cage, whose interest in Zen Buddhism influenced Lippold's use of variation and continuity. From the late 1950s on, Lippold became increasingly interested in executing public commissions because they permitted experiments with scale and required the integration of the viewer's entire spatial environment.

Lippold first exhibited at the Detroit Institute of Arts in 1945 and had his first one-artist show at the Willard Gallery, New York, in 1947. Three years later, his first major large-scale work, *Variation Number 7 Full Moon*, was exhibited at The Museum of Modern Art, New York, and in 1950 Walter Gropius commissioned sculpture from him for the Graduate Law Center at Harvard University. In 1953, The Metropolitan Museum of Art, which rarely commissions works, asked Lippold to create the sculpture now entitled *The Sun*. Since then, he has frequently accepted architectural commissions, including the monumental *Apollo and Orpheus*, created in 1962 for the lobby of the New York Philharmonic (now Avery Fisher) Hall at Lincoln Center in New York City.

The Whitney Museum included Lippold's work in its 1947 painting and sculpture Annual; it has represented him in twelve subsequent exhibitions, and acquired *Primordial Figure* (1947–48) in 1962.

Fig. 68. Richard Lippold, *Primordial Figure*, 1947–48. Brass and copper wire, 96 x 24 x 18″ (243.8 x 61 x 45.7 cm). Whitney Museum of American Art, New York; Gift of the Friends of the Whitney Museum of American Art, Charles Simon (and purchase) 62.27.

Campbell, Lawrence. "Lippold Makes a Construction." *Art News*, 55 (October 1956), pp. 31–33.

Kaufmann, Edgar, Jr. "Fresh Aspects of American Art: The Inland Steel Building and Its Art." *Art in America*, 45 (Winter 1957–58), cover and pp. 22–27.

Lippold, Richard. "Sculpture?" *Magazine of Art*, 44 (December 1951), pp. 315–19.

———. "How to Make a Sculpture." *Art in America*, 44 (Winter 1956–57), pp. 27–29.

———. "Projects for Pan Am and Philharmonic." *Art in America*, 50 (Summer 1962), pp. 50–55.

———. *Richard Lippold 1952–1962* (exhibition catalogue). New York: Willard Gallery, 1962.

Miller, Dorothy C., ed. *15 Americans* (exhibition catalogue). New York: The Museum of Modern Art, 1952.

Tomkins, Calvin. "Profiles: A Thing Among Things." *The New Yorker*, March 30, 1963, pp. 47–107.

Seymour Lipton

Born 1903

Born in New York City. Lipton, who has no formal art training, attended Brooklyn Polytechnical Institute, City College of New York, and Columbia University, earning a degree in dentistry in 1927. He taught sculpture at the New School for Social Research (1940–65), Cooper Union (1943), New Jersey State Teachers College (1944–46), and Yale University Art School (1957–59).

By the mid-1930s, although still a practicing dentist, Lipton was devoting most of his time to sculpture, working mainly in carved wood and plaster. His early work reflected a deep concern with social and political issues, but by the mid-1940s he had turned away from strictly narrative subjects and toward a biomorphic, Surrealist-influenced idiom. At this time, he started using metal predominantly, and in 1949 invented his characteristic technique of brazing bronze and nickel silver rods onto sheet metal with an oxyacetylene torch; at first he used sheet steel as a base and then, from 1955 on, the rust-proof, white bronze alloy Monel metal. This flexible process allowed him to create open and solid shapes of any curvature and provided him with a wide range of surface color and texture. Lipton arrived at his mature style around 1950, maintaining an interest in loosely metaphoric organic abstractions but working with simpler, larger curving forms and fewer clearly anatomical allusions. While he has executed a number of large outdoor commissions, the scale of his work remains fundamentally human.

Lipton exhibited for the first time in a 1933–34 group show at the John Reed Club Gallery, New York, entitled "Paintings, Sculpture, Drawings, Prints on the Theme Hunger, Fascism, War." He had his first one-artist show, of wood sculptures, in 1938 at the ACA Gallery, New York. He represented the United States at the São Paolo Biennale (1957) and at the Venice Biennale (1958). Major one-artist shows of his work have been presented by the Phillips Collection, Washington, D.C. (1963), the Milwaukee Art Center (1969), the Hayden Art Gallery, Massachusetts Institute of Technology (1971), the National Collection of Fine Arts, Washington, D.C. (1979), and The Jewish Museum, New York (1979). Among his many architectural commissions are three sculptures for Temple Israel in Tulsa, Oklahoma (1953); *Argonaut I & II* for the IBM Watson Research Center, Yorktown Heights, New York (1960–61); and *Archangel* for the New York Philharmonic (now Avery Fisher) Hall at Lincoln Center, New York City (1963–64).

The Whitney Museum has represented Lipton in thirty-four exhibitions, beginning with the 1948 Annual. His work first entered the Permanent Collection with the Museum's acquisition of *Thunderbird* (1951–52) in 1953; two other sculptures and four drawings have been acquired since.

Fig. 69. Seymour Lipton, *Earth Forge II*, 1955. Nickel-silver on steel, 31⅛ x 52⅝ x 19¼ " (79.1 x 133.7 x 48.9 cm). The Brooklyn Museum; Dick S. Ramsay Fund.

Chaet, Bernard. "Direct Metal Sculpture: Interview with Seymour Lipton." *Arts*, 32 (April 1958), pp. 66–67.

Elsen, Albert E. "Seymour Lipton: Odyssey of the Unquiet Metaphor." *Art International*, 5 (February 1, 1961), pp. 39–44.

———. "The Sculptural World of Seymour Lipton." *Art International*, 9 (February 1965), pp. 12–16.

———. *Seymour Lipton*. New York: Harry N. Abrams, 1974.

Hunter, Sam. *Seymour Lipton* (exhibition catalogue). New York: Marlborough-Gerson Gallery, March 1965.

———. *Seymour Lipton: Sculpture* (exhibition catalogue). Charlotte, North Carolina: Mint Museum of Art, 1982.

Lipton, Seymour. "Some Notes on My Work." *Magazine of Art*, 40 (November 1947), pp. 264–65.

———. "Experience and Sculptural Form." *College Art Journal*, 9 (Autumn 1949), pp. 52–54.

———. "Art in the USA: Artists Say: S. Lipton." *Art Voices*, 4 (Spring 1965), pp. 88–89.

———. "Extracts from a Notebook." *Arts Magazine*, 45 (March 1971), pp. 34–36.

———. "The Grotesque and Classical in Sculpture." *Tracks*, 3 (Spring 1977), pp. 78–81.

Miller, Dorothy C., ed. *12 Americans* (exhibition catalogue). New York: The Museum of Modern Art, 1956.

Rand, Harry. *Seymour Lipton: Aspects of Sculpture* (exhibition catalogue). Washington, D.C.: National Collection of Fine Arts, Smithsonian Institution, 1979.

Ritchie, Andrew Carnduff. "Seymour Lipton." *Art in America*, 44 (Winter 1956–57), pp. 14–17.

Rosenstein, Harris. "Lipton's Code." *Art News*, 70 (March 1971), pp. 46–47, 64–65.

Reuben Nakian

Born 1897

Born in College Point, New York. In his youth, Nakian worked as a commercial artist in New York. He briefly attended the Art Students League in 1912, the Independent Art School (directed by Robert Henri) and the Beaux-Arts Institute of Design in 1915. From 1916 to 1920, he worked in the studio of sculptor Paul Manship under Manship's assistant Gaston Lachaise, with whom he shared a studio from 1920 to 1923. In 1948, he moved from New York to Stamford, Connecticut, where he still resides.

Nakian's early work, in wood, marble, and stone, concentrated on animal subjects and, by the early 1930s, included occasional portraits. In 1933, he received a commission to execute a portrait of National Recovery Act Director Hugh Johnson. Buoyed by its success, Nakian briefly established himself in Washington, D.C., where he proceeded to portray Franklin Roosevelt and his cabinet. Though widely shown and publicized, the plaster "New Deal Hall of Fame" busts, as they were called, produced no income for the artist and, following completion of the heroic and much acclaimed eight-foot-tall portrait of *Babe Ruth* in 1934, Nakian stopped making sculpture for some years. Little of his work from the late 1930s survives. By the end of the decade, he was making terracotta and plaster sketches, and in 1943 returned decisively to sculpture. The work that followed was in a much freer style than that of the thirties, and in the mid-forties he began to develop the mythological-erotic themes, beginning with the Europa series, that would recur in his subsequent work.

While teaching at the Newark School of Fine and Industrial Arts (1946–51), he had access to an exceptionally big kiln, which he used to create correspondingly large terracotta sculptures. Some of these were cast in bronze. The highly textured work of this period achieved an almost painterly play of light and shadow.

Nakian turned to welded and painted steel in *The Rape of Lucrece* (1955–58), a work which proved influential to John Chamberlain and Mark di Suvero, among others, in its resolution of a spare syntax and sensual subject matter. In the mid-1960s, Nakian returned, however, to casting in bronze from works modeled in terracotta, plaster, and burlap, thereby regaining the textural range and gestural freedom he relished. His 6,700-pound *Descent from the Cross* was installed at St. Vartan's Armenian Cathedral, New York, in 1978.

In 1923, Nakian exhibited with John Dos Passos (a watercolorist as well as a writer) and Adelaide Lawson at the Whitney Studio Club, which awarded him a monthly stipend of $250 and also gave him his first one-artist show, in 1926. After exhibiting widely in galleries and museums, Nakian was given a major retrospective in 1966 at The Museum of Modern Art, New York, and in 1968 he represented the United States at the Venice Biennale. In the past three years, he has had one-artist exhibitions at the Hirshhorn Museum and Sculpture Garden, Smithsonian Institution, Washington, D.C., and at the National Portrait Gallery, Washington, D.C.

In 1951, the Whitney Museum purchased *The Lap Dog* (1927), *Seal* (1930), and five drawings; it has acquired three sculptures since and represented Nakian in seventeen group shows.

Fig. 70. Reuben Nakian, *Olympia*, 1961. Bronze, 72 x 74 x 27″ (182.9 x 188 x 68.6 cm). Whitney Museum of American Art, New York; Gift of the Friends of the Whitney Museum of American Art (and purchase) 63.48.

Arnason, H. H. "Nakian." *Art International*, 7 (April 25, 1963), pp. 36–43.

Goldwater, Robert. "Reuben Nakian." *Quadrum*, 11 (1961), pp. 95–102.

Hess, Thomas B. "Introducing the Steel Sculpture of Nakian: The Rape of Lucrece." *Art News*, 57 (November 1958), pp. 36–39, 65–66.

———. "Today's Artists: Nakian." *Portfolio and Art News Annual*, no. 4 (1961), pp. 84–99, 168–72.

———. *Nakian* (exhibition catalogue). Washington, D.C.: The Washington Gallery of Modern Art, 1963.

———. "In Praise of Reason." *Art News*, 65 (Summer 1966), pp. 22–25, 60.

Nordlund, Gerald. *Reuben Nakian* (exhibition catalogue) New York: Marlborough Gallery, 1982.

O'Hara, Frank. *Nakian* (exhibition catalogue). New York: The Museum of Modern Art, 1966.

Louise Nevelson

Born 1900

Born Louise Berliawsky in Kiev, Russia. Nevelson's family moved to Rockford, Maine, in 1905, where her father became a realtor, contractor, and lumberyard owner. In 1920, she moved to New York City, studying singing and drama as well as painting and drawing. She attended the Art Students League (1928, 1930) and studied briefly with Hans Hoffman in Munich in 1931. In 1932, having returned to New York, she assisted Diego Rivera on several mural projects and resumed courses at the Art Students League with Hoffman and George Grosz; she also took lessons in modern dance. After World War II, Nevelson traveled to Europe and then repeatedly to Central and South America, where she was introduced to Mayan art.

Nevelson's work of the 1930s and early 1940s, in a wide assortment of media, including plaster, terracotta, stone, metal, and wood, reflected equally diverse stylistic influences. Among them, Cubist spatial organization and the Surrealist advocacy of found objects would continue to inform her work, as would a progressively deeper appreciation of Pre-Columbian and other non-Western art and architecture. Her early choice of wood, which still predominates in her work, resulted from her esteem for its architectural connotations and its adaptability, rather than from an interest in its organic essence or particular surface texture (the qualities most important to direct-carve sculptors). Hence, she has always painted the surfaces of her wood sculptures a uniform color, usually black or white. Her first tabletop assemblages of found-wood objects date from the late 1940s. By the middle of the next decade, she had developed the basics of her sculptural vocabulary: the boxes, quasi-anthropomorphic columns and, finally, the freestanding wall reliefs, all composed of assembled compartments of painted found-wood objects. In 1958, she created her first environment, the black wood *Moon Garden + One*. This dimly lit, densely packed installation, which included the large wall piece *Sky Cathedral* (1958), transformed the Grand Central Moderns Gallery into a theatrical space. This sense of theatricality has come to characterize Nevelson's installation pieces. *Dawn's Wedding Feast*, a white environment made for The Museum of Modern Art's "16 Americans" exhibition, followed in 1959, and *Royal Tides*, the first gold-painted assemblage, was shown in 1961 at the Martha Jackson Gallery, New York. In the mid-1960s, Nevelson briefly used reflective and transparent materials—mirrors and Plexiglas. In 1966, she made her first large metal works.

Nevelson had her first one-artist show, of sculpture and painting, in 1941 at the Nierendorf Gallery, New York; she has shown since at other galleries and at many museums in this country and abroad. She was among the American representatives in the 1962 Venice Biennale. In 1969, Princeton University commissioned her first monumental outdoor work, which was followed by numerous commissions, including a work for the interior of St. Peter's Lutheran Church, Citicorp Center, New York (1977), and one for Louise Nevelson Plaza in Lower Manhattan (1978). Nevelson lives and works in New York.

In 1956, the Whitney Museum acquired *Black Majesty* (1955), becoming the first museum to own Nevelson's work; it now owns seventeen sculptures and has been promised two others. There are also thirteen works on paper and seventeen prints by Nevelson in the Permanent Collection. The Museum presented her first museum retrospective in 1967 and a second solo show in 1980. It has represented her in thirty-four group exhibitions.

Fig. 71. Louise Nevelson, *Black Majesty*, 1955. Wood, 27⅞ x 9½ x 32″ (70.8 x 24.1 x 81.3 cm). Whitney Museum of American Art, New York; Gift of Mr. and Mrs. Ben Mildwoff through the Federation of Modern Painters and Sculptors, Inc. 56.11.

Friedman, Martin. *Nevelson: Wood Sculptures* (exhibition catalogue). Minneapolis: Walker Art Center in cooperation with E. P. Dutton, New York, 1973.

Glimcher, Arnold B. *Louise Nevelson.* Second revised ed. New York: E. P. Dutton, 1976.

Gordon, John. *Louise Nevelson* (exhibition catalogue). New York: Whitney Museum of American Art in cooperation with Praeger Publishers, 1967.

Kramer, Hilton. "The Sculpture of Louise Nevelson." *Arts,* 32 (June 1958), pp. 26–29.

———. "Nevelson: Her Sculpture Changed the Way We Look at Things." *The New York Times Magazine,* October 30, 1983, pp. 28–30, 69, 72–73, 81.

Lipman, Jean. *Nevelson's World.* New York: Hudson Hills Press in association with the Whitney Museum of American Art, 1983.

Martha Jackson Gallery, New York. *Nevelson* (exhibition catalogue). Foreword by Kenneth Sawyer, poem by Jean Arp, commentary by Georges Mathieu, 1961.

Miller, Dorothy C., ed. *16 Americans* (exhibition catalogue). New York: The Museum of Modern Art, 1959.

Nevelson, Louise. "Nevelson on Nevelson." *Art News,* 71 (November 1972), pp. 66–68.

Nevelson, Louise, and Diana MacKown. *Dawns + Dusks* (taped conversations with Diana MacKown). New York: Charles Scribner's Sons, 1976.

Rosenblum, Robert. "Louise Nevelson." *Arts Yearbook 3, Paris/New York* (1959), pp. 136–39.

Wilson, Laurie. *Louise Nevelson: Iconography and Sources.* New York: Garland Publishing, 1981.

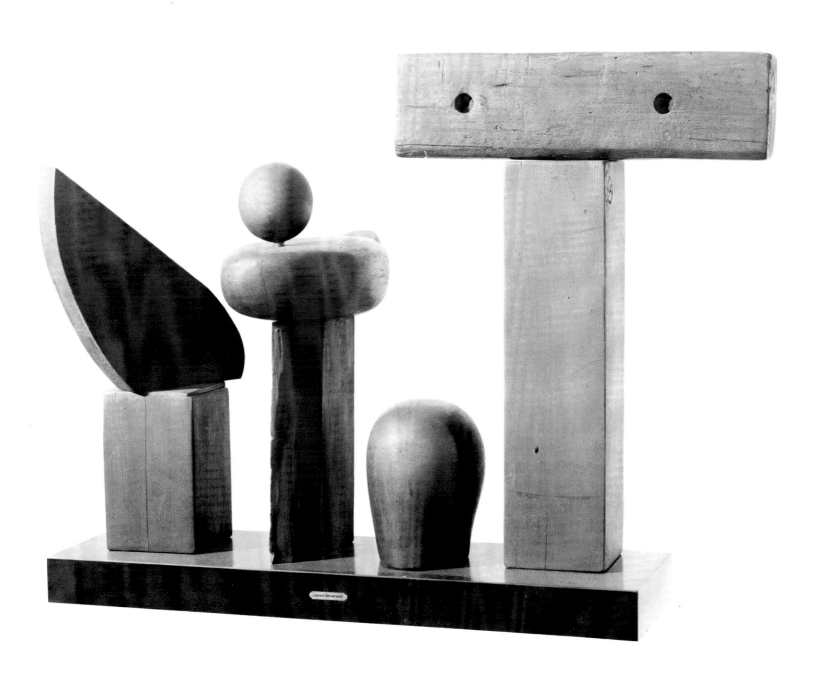

Isamu Noguchi

Born 1904

Born in Los Angeles. Noguchi, whose father was a Japanese poet, moved to Japan in 1906 with his mother, a writer and teacher of Scotch-Irish descent. In 1918, he was sent back to the United States to attend school. Having become interested in art, he worked briefly in Connecticut in 1922 for Gutzon Borglum, sculptor of the Mount Rushmore monument, who discouraged him from continuing with sculpture. Noguchi attended Columbia University as a pre-medical student (1922–24), but by 1924 was taking art classes at the Leonardo da Vinci School. In 1927, he went to Paris, where he worked in Constantin Brancusi's studio and at the Académie de la Grande Chaumière and the Collarosi School. In 1929, he returned to New York, but left again in 1931, traveling to China and Japan via Europe in the first of many trips to the Orient. This sojourn afforded him expertise in such traditional media as ink-brush painting and pottery and marked an important break in Noguchi's career. The skills he learned there, and his understanding of the Japanese sensitivity to spatial organization and natural materials, would have a continuing impact on his work. He now divides his time between New York and Japan.

Noguchi's work of the late 1920s included sleek abstractions indebted to Brancusi, portrait heads (which at the time provided the bulk of his income) and, briefly in the mid-1930s, explicitly symbolic representational sculpture. In 1938, he was awarded the commission for a stainless steel relief celebrating journalism over the entrance to the Associated Press Building in Rockefeller Center.

A remarkably versatile artist, Noguchi designed the first set used by the Martha Graham Dance Company (1935), which initiated his long involvement with dance and theater set design. In the late 1930s, he began experimenting with furniture design, and in 1944, he created a coffee table (still in production by the Herman Miller Company). Also in the late 1930s, he began to create ambitious designs for fountains, parks, and playgrounds. By 1945, the biomorphic forms of Noguchi's sculpture reflected a deepening interest in Surrealism. From the late 1950s, he has worked increasingly with metals, in a more geometric vocabulary, although he never completely abandoned organic imagery or materials.

Noguchi's first one-artist show opened at the Egon Schoen Gallery, New York, in 1929. In 1942, he had a one-artist show at the San Francisco Museum of Art. Since then, his work has been widely exhibited both here and abroad. His first public design commission, a garden for the Reader's Digest Building in Tokyo, was completed in 1951. Other major commissions for outdoor work have included two bridges for the Hiroshima Peace Park (1951–52), sculpture for the UNESCO Gardens, Paris (1958), and a sunken rock garden for the Chase Manhattan Bank Plaza, New York (1965).

The Whitney Museum has presented two one-artist shows of Noguchi's work, one in 1968 and another in 1980, and has included him in forty-nine exhibitions, beginning with the 1939 Annual. His work first entered the Permanent Collection with the 1931 acquisition of a bronze portrait bust, *Ruth Parks* (1929). The Museum now owns one Noguchi drawing and eight sculptures; it has been promised three additional sculptures.

Fig. 72. Isamu Noguchi, *The Gunas*, c. 1948. Tennessee marble, 73¼ x 26¼ x 25½ʺ (186.1 x 66.7 x 64.8 cm). Whitney Museum of American Art, New York; Gift of the Howard and Jean Lipman Foundation, Inc. 75.18.

Friedman, Martin. *Noguchi's Imaginary Landscapes* (exhibition catalogue). Minneapolis: Walker Art Center, 1978.

Fuller, Buckminster. "Noguchi." *The Palette* (Winter 1960), entire issue.

Gordon, John. *Isamu Noguchi* (exhibition catalogue). New York: Whitney Museum of American Art, 1968.

Grove, Nancy, and Diane Botnick. *The Sculpture of Isamu Noguchi, 1924–79.* New York: Garland Publishing, 1980.

Gruen, John. "The Artist Speaks—Isamu Noguchi." *Art in America*, 56 (March-April 1968), pp. 28–31.

Hess, Thomas B. "Isamu Noguchi." *Art News*, 45 (September 1946), pp. 34–38, 47, 50–51.

Hunter, Sam. *Isamu Noguchi.* New York: Abbeville Books, 1978.

Kuh, Katharine. "An Interview with Isamu Noguchi." *Horizon*, 11 (March 1960), pp. 104–12.

Michelson, Annette. *Isamu Noguchi* (exhibition catalogue). Paris: Galerie Claude Bernard, 1964.

———. "Noguchi: Notes on a Theatre of the Real." *Art International*, 8 (December 1964), pp. 21–25.

Noguchi, Isamu. "Meanings in Modern Sculpture." *Art News*, 48 (March 1949), pp. 12–15.

———. *A Sculptor's World.* Foreword by R. Buckminster Fuller. New York: Harper & Row, 1968.

———. *Isamu Noguchi: The Sculpture of Spaces* (exhibition catalogue). Foreword by Tom Armstrong. New York: Whitney Museum of American Art, 1980.

Page, Addison Franklin. "Isamu Noguchi, the Evolution of a Style." *Art in America*, 44 (Winter 1956–57), pp. 24–26, 64–66.

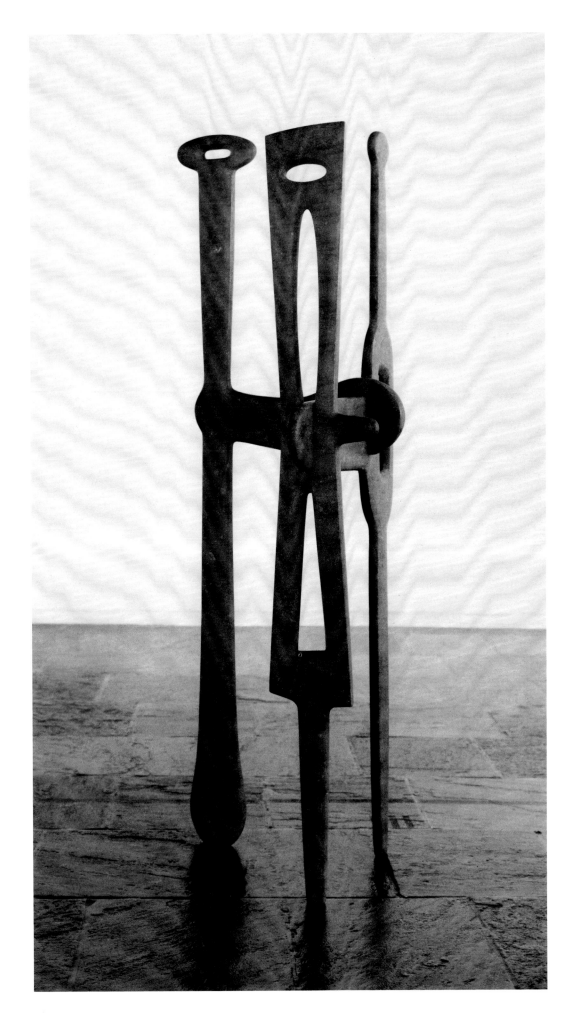

Theodore Roszak

(1907–1981)

Born in Poznan, Poland. Roszak's family moved to Chicago in 1909. His mother, a former fashion designer, encouraged his interest in art, and while still in high school he began attending classes at the School of The Art Institute of Chicago, enrolling there full time in 1925. A year later, he moved to New York, studying at the National Academy of Design, taking private classes with George Luks, and attending philosophy courses at Columbia University. Between 1927 and 1929, he was again at The Art Institute of Chicago, completing his studies and teaching there. During this time, he returned briefly to the East Coast and experimented with lithography in Woodstock, New York. In 1929, he went to Europe, traveling in France, Germany, Italy, and Czechoslovakia. The modern paintings he saw in Paris, especially those of Juan Gris and Giorgio de Chirico, were important revelations to Roszak. But it was the Bauhaus-influenced machine art that he saw in Prague, where he established a studio, that affected him most deeply. On his return to New York in 1931, he took up residence at the Tiffany Foundation's Long Island artists' colony. The following year, he moved to Staten Island, where—with additional Tiffany Foundation support—he took courses in machine shop techniques. From 1938 to 1940, he taught under Frederick Kiesler at the Bauhaus-oriented Design Laboratory in New York. During World War II, he worked for an aircraft corporation and learned industrial welding and brazing.

In the early 1930s, Roszak became interested in the possibility of an ideal society based on cooperation between art and industry. Primarily a painter and a graphic artist until this time, he now began to create geometric clay and plaster assemblages (although he never abandoned work in two dimensions). His first machined-metal sculpture, *Air-port Structure* (in which the evidence of his toolmaking experience is clear), was made in 1932. From around 1937 to 1945, his main sculptural production was of streamlined, pseudo-industrial objects. Following the war, however, Roszak gave up the machine aesthetic because it failed to accommodate the emotional range he felt increasingly compelled to convey. Working primarily in welded and brazed steel from 1947 on, and increasingly on large-scale public commissions, he developed a Surrealist-influenced style using organic and often violent imagery associated with the unconscious. The highly wrought surfaces of these open welded sculptures matched the violence of their subjects.

Roszak's first one-artist show, of lithographs, took place in 1928 at the Allerton Galleries, Chicago. For fifty years, he continued to have one-artist shows at major New York galleries and at museums throughout the country—the Walker Art Center, Minneapolis (1956), the Arts Club, Chicago (1957), the Hayden Gallery at M.I.T. (1979) and, most recently, at the Whitney Museum (1983). Among his major public commissions are a spire and bell tower for Eero Saarinen's Chapel at M.I.T., realized in 1956, and a thirty-seven-foot-wide eagle installed on the façade of the American Embassy in London in 1960.

Roszak was included in the Whitney Museum's first Annual in 1932, and he has been included in forty-five shows at the Museum since. His work entered the Permanent Collection with the 1934 acquisition of the painting *Fisherman's Bride* (1934); the first sculpture acquired was *Thorn Blossom* (1948) in 1948. The Museum now owns four more sculptures and thirty-one works on paper by Roszak; eleven of the latter entered the Permanent Collection in 1983 as the Theodore Roszak Bequest.

Fig. 73. Theodore Roszak, *Spectre of Kitty Hawk*, 1946–47. Welded and hammered steel brazed with bronze and brass, 40¼ ″ (102.2 cm) high; base 18 x 15″ (45.7 x 38.1 cm). The Museum of Modern Art, New York; Purchase.

Arnason, H. H. *Theodore Roszak* (exhibition catalogue). Minneapolis: Walker Art Center, 1956.
———. "Growth of a Sculptor, Theodore Roszak." *Art in America*, 44 (Winter 1956–57), pp. 21–23, 61–64.
Griffin, Howard. "Totems in Steel." *Art News*, 55 (October 1956), pp. 34–35, 64–65.
Krasne, Belle. "A Theodore Roszak Profile." *Art Digest*, 27 (October 15, 1952), pp. 9, 18.
McBride, Henry. "By Henry McBride: Roszak's Moral Lesson." *Art News*, 50 (May 1951), p. 46.
Pachner, Joan. "Theodore Roszak and David Smith: A Question of Balance." *Arts Magazine*, 58 (February 1984), pp. 102–13.
Pierre Matisse Gallery. *Theodore Roszak Sculpture* (exhibition catalogue). Statements by the artist and Lionel Abel. New York: 1962.
Roszak, Theodore. "Modern Sculpture and American Legend." Unpublished transcript of a talk sponsored by the Whitney Museum of American Art for WNYC, New York, 1953. Whitney Museum Files.
———. "Some Problems of Modern Sculpture." *Magazine of Art*, 42 (February 1949), pp. 53–56.
———. "In Pursuit of an Image." *Quadrum*, 2 (November 1956), pp. 49–60.
Sawin, Martica. "Theodore Roszak: Craftsman and Visionary." *Arts*, 31 (November 1956), pp. 18–19.

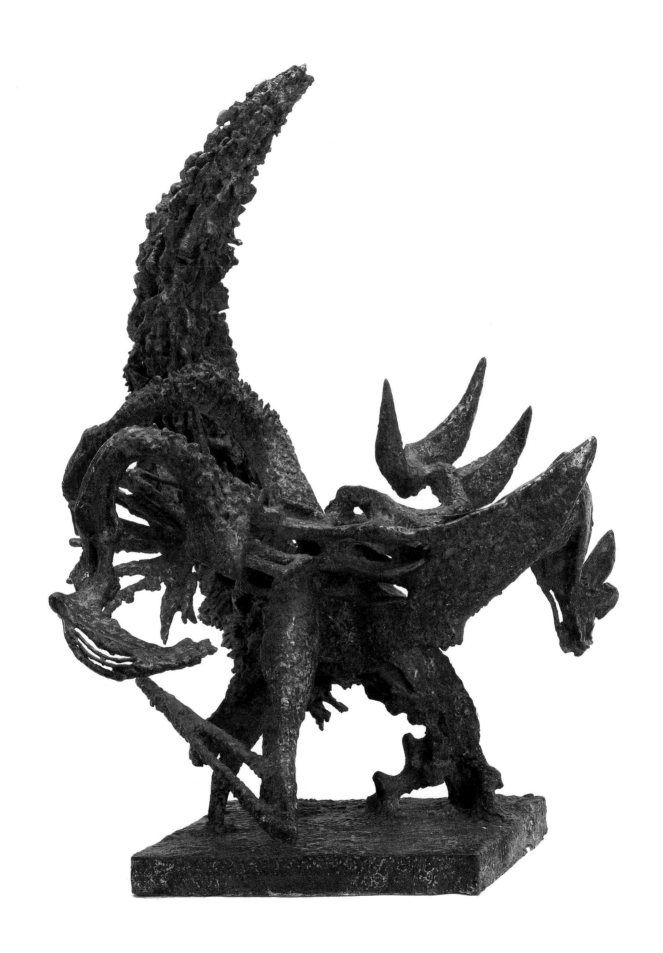

David Smith

(1906–1965)

Born in Decatur, Indiana. Smith moved to Ohio in 1921 and attended Ohio University for one year (1924). He then entered Notre Dame University, but by 1926 was living in Washington, D.C., taking courses in art and poetry at George Washington University. That same year, he moved to New York, studying at the Art Students League with Jan Matulka and John Sloan until 1932. Between 1933 and 1940, he rented a studio space at the Terminal Iron Works in Brooklyn. (When he moved permanently to an old farm at Bolton Landing, New York, in 1940, Smith gave his studio there the same name.) In 1937, he was employed by the WPA; during World War II, he worked at the American Locomotive Company in Schenectady, New York, as a welder.

Smith began his career as a painter, but in the early 1930s started to attach found materials to his paintings' surfaces. In 1932, he made his first freestanding constructions, of wood and found materials, and in 1933 began to weld. That year he completed a group of *Heads*, which may have been the first painted, welded steel sculptures produced in America. By 1936, he was concentrating on sculpture, yet throughout his career he continued to explore options traditionally considered painterly, including planar composition and color. During the 1930s and into the 1940s, he used a variety of processes and metals, working with welded assemblages of discarded machine parts, solid cast forms, and open linear frameworks to create heads, full figures, and biomorphic abstractions. The *Medals for Dishonor* (1938–40), a somewhat anomalous, highly graphic series of bronze medals condemning social and political abuses, won Smith his first wide recognition.

In Smith's work of the mid-1940s, Surrealist figurative influence was particularly evident. At the end of the decade, non-axial compositions that defied the traditional spatial logic of monolithic sculpture appeared in such seminal pieces as *Blackburn, Song of an Irish Blacksmith* (1949–50) and *Hudson River Landscape* (1951). These compositions were characterized by open construction, centrifugal dispersion of forms and, frequently, a strong horizontal thrust. By 1951, Smith had also committed himself almost exclusively to welded steel and iron. The Tanktotem series, begun in 1952, introduced the totemic forms that would figure prominently in his succeeding work. In 1956, Smith began to use the strict geometry that was fully realized in his Cubi series, begun in 1963.

Smith had his first one-artist show in 1938 at the East River Gallery, New York. In 1957, he had a one-artist show at The Museum of Modern Art, New York; he had a second one-artist show there in 1963, and a third in 1966. The Solomon R. Guggenheim Museum, New York, presented a retrospective in 1969; the Hirshhorn Museum and Sculpture Garden, Washington, D.C., has had two surveys of his work (1979 and 1982); and his sculpture has also been shown widely abroad.

The Whitney Museum first included Smith's work in its 1941 Annual. His sculpture has since appeared in thirty-nine group exhibitions at the Museum, which also organized "David Smith: The Drawings" (1980). *Cockfight—Variation* (1945), the first of five sculptures and twelve drawings to enter the Permanent Collection, was acquired in 1946.

Fig. 74. David Smith, *Tanktotem IV*, 1953. Steel, 92⅝ x 29 x 34″ (235.3 x 73.7 x 86.4 cm). Albright-Knox Art Gallery, Buffalo; Gift of Seymour H. Knox.

Carmean, E. A., Jr. *David Smith* (exhibition catalogue). Washington, D.C.: National Gallery of Art, 1982.

Cone, Jane Harrison, and others. *David Smith 1906–1965: A Retrospective Exhibition* (exhibition catalogue). Cambridge, Massachusetts: Harvard University, Fogg Art Museum, 1966.

Fry, Edward F. *David Smith* (exhibition catalogue). New York: The Solomon R. Guggenheim Foundation, 1969.

————, and Miranda McClintic. *David Smith: Painter, Sculptor, Draftsman* (exhibition catalogue). New York: George Braziller, in association with the Hirshhorn Museum and Sculpture Garden, Smithsonian Institution, Washington, D.C., 1982.

Goossen, Eugene C. "David Smith." *Arts*, 30 (March 1956), pp. 23–27.

Gray, Cleve, ed. *David Smith by David Smith*. New York: Holt, Rinehart & Winston, 1968.

Greenberg, Clement. "David Smith." *Art in America*, 44 (Winter 1956–57), pp. 30–33, 66.

Kramer, Hilton. "The Sculpture of David Smith." *Arts*, 34 (February 1960), pp. 22–41.

Krauss, Rosalind. "The Essential David Smith." *Artforum*, 7 (February 1969), pp. 43–49.

————. *Terminal Iron Works: The Sculpture of David Smith*. Cambridge, Massachusetts: The M.I.T. Press, 1971.

————. *The Sculpture of David Smith: A Catalogue Raisonné*. New York: Garland Publishing, 1977.

McCoy, Garnett, ed. *David Smith*. Writings by the artist. New York: Praeger Publishers, 1973.

Porter, Fairfield. "David Smith: Steel into Sculpture." *Art News*, 56 (September 1957), pp. 40–43, 54–55.

Smith, David. "Notes on My Work." *Arts Magazine*, 34 (February 1960), pp. 44–49.

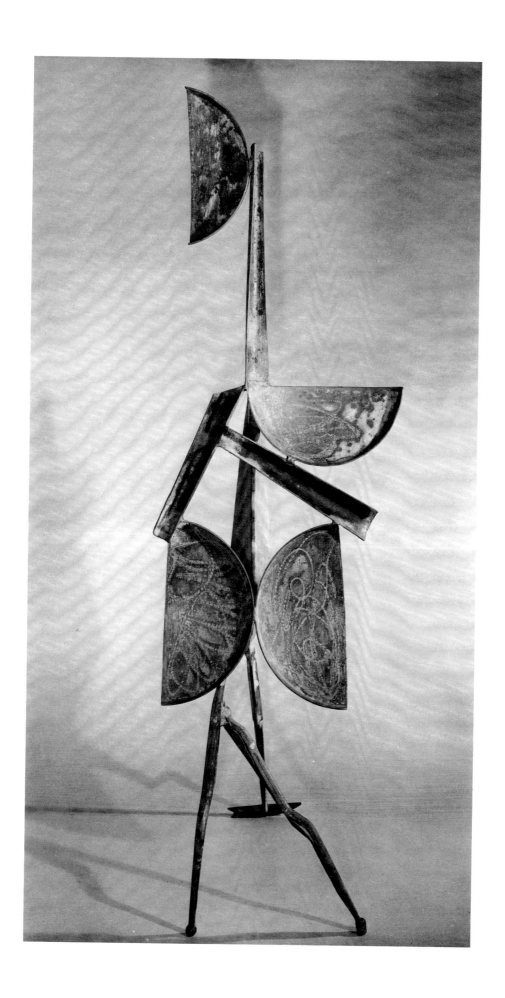

Richard Stankiewicz

(1922–1983)

Born in Philadelphia to Polish parents. Following the death of his father in 1928, Stankiewicz moved with his family to Detroit, living near a foundry dump in which he rummaged for scraps to make toys. He served in the navy (1941–47) and was stationed for a while in Seattle; there he met Mark Tobey and Morris Graves, who encouraged his interest in painting. Following his discharge, he moved to New York and studied at the Hans Hoffman School (1948–50). In 1950, he traveled to Paris, studying at the ateliers of Fernand Léger and Ossip Zadkine. Stankiewicz returned to New York in 1951 and a year later became a founding member of the cooperative Hansa Gallery. In 1962, he moved permanently to western Massachusetts. Between 1969 and 1982, he taught at the State University of New York at Albany.

Stankiewicz made his first sculptures during a wartime tour of the Pacific, carving figures out of caribou bone while in the Aleutians and making his first abstract sculpture, in wood, while in Hawaii. In New York after World War II, he pursued painting but turned decisively to sculpture during his sojourn in Paris. He initially worked in terracotta and plaster, but by 1951 he was incorporating the found "junk" objects that would be his trademark for the next decade.

In 1954, he began welding, continuing to distill loosely figurative forms from objects selected for the visual puns and organic resemblances they suggested. During the 1960s, his work became less figurative and more geometricized. The facilities of a metal fabrication plant were made available to him during a 1969 trip to Australia; in two months there he completed fifteen works welded from newly milled I-beams, T-beams, rectangular planes, and cylinders. After his return to America, he continued to use regular, fabricated forms, though he never entirely abandoned his interest in representation.

Stankiewicz had his first one-artist show in 1953 at the Hansa Gallery, New York, where he exhibited at least annually through 1958. For the next six years, he was represented by the Stable Gallery, New York, and from 1972 on by the Zabriskie Gallery, New York, which presented a small retrospective of his work in 1983. In 1979, the University Art Gallery of the State University of New York at Albany organized a survey of Stankiewicz's sculpture which traveled to three other institutions.

The Whitney Museum, which showed Stankiewicz's work initially in 1956, and in thirteen group shows since, owns three of his sculptures. The first piece to enter the Permanent Collection was *Kabuki Dancer*, acquired in 1957.

Fig. 75. Richard Stankiewicz, *Kabuki Dancer*, 1956. Cast iron and steel, on wooden base, 84 x 25 x 26″ (213.4 x 63.5 x 66 cm). Whitney Museum of American Art, New York; Gift of the Friends of the Whitney Museum of American Art 57.12.

Geist, Sidney. "Miracle in the Scrapheap." *Art Digest*, 28, (December 1953), p. 10.

Hultén, K. G. Pontus. *The Machine as Seen at the End of the Mechanical Age* (exhibition catalogue). New York: The Museum of Modern Art, 1968.

Kramer, Hilton. "Month in Review." *Arts Magazine*, 33 (January 1959), pp. 50–51.

Miller, Dorothy C., ed. *16 Americans* (exhibition catalogue). Statement by Stankiewicz. New York: The Museum of Modern Art, 1959, p. 70.

Porter, Fairfield. "Stankiewicz Makes a Sculpture." *Art News*, 54 (September 1955), pp. 36–39.

Sandler, Irving. *The Sculpture of Richard Stankiewicz* (exhibition catalogue). Albany, New York: University Art Gallery, State University of New York at Albany, 1979.

————. "Stankiewicz's 'Personages.'" *Art in America*, 68 (January 1980), pp. 84–87.

Sawin, Martica. "Richard Stankiewicz." *Arts Yearbook 3, Paris/New York* (1959), pp. 156–59.

Stankiewicz, Richard. "Prospects for American Art." *Arts*, 30 (September 1956), pp. 16–17.

Van der Marck, Jan. *Richard Stankiewicz, Robert Indiana* (exhibition catalogue). Minneapolis: Walker Art Center, in collaboration with the Institute of Contemporary Art, Boston, 1963.

Wright, Clifford. "Stankiewicz—Junk Poet." *Studio*, 164 (1962), pp. 2–5.

George Sugarman

Born 1912

Born in New York City. As a teenager, Sugarman accompanied his father, an Oriental-rug dealer, on selling trips throughout the eastern and southern states. Sugarman attended City College of New York (B.A., 1934). Between 1935 and 1940, he held a variety of jobs, including arts and crafts teacher under the WPA and welfare department investigator. He served in the navy on a Pacific tour (1941–45), and after the war took evening classes at The Museum of Modern Art, New York. In 1951, at the age of thirty-nine, he went to Paris to study with Ossip Zadkine. He stayed in Europe for three years, attending the Académie de la Grande Chaumière (1952–53) and traveling widely. The Italian Baroque architecture of Bernini and Borromini, and Antoni Gaudi's Art Nouveau buildings in Barcelona particularly intrigued him. He was also struck by the spatial experience of French Gothic tombstone reliefs embedded in the floor.

While still in Paris, he produced *Three Abstract Figures* (1952–53), his first sculpture meant to be seen below eye level, as well as his first horizontal work. On his return to New York in 1955, he continued to work in wood, but abandoned carving to avoid the anthropomorphic associations that the tree trunk imposed. Instead, he began to use laminated wood, a more flexible material which allowed for such additive, relatively spontaneous compositions as the segmented, horizontal *Six Forms in Pine* (1959). At this time he became interested in the "endless" compositions of Jackson Pollock's drip paintings. Sugarman sought a formal unity achieved through the juxtaposition of disparate, even contradictory elements, and began to use color to simultaneously distinguish his sculpture's component parts and establish expressive relationships among them. *Yellow Top* (1959) was his first painted sculpture; with David Smith and John Chamberlain, Sugarman became one of the few sculptors to use applied color extensively. After his first floor piece, *Inscape* (1964), Sugarman's work grew substantially in scale and complexity, and by 1969 he found wood too restrictive. He has worked in painted metal, and frequently on large-scale outdoor public commissions, since then.

In 1956, Sugarman became a founding member of the New Sculpture discussion group and also of the cooperative Brata Gallery. He had his first one-artist show, of carved wood sculpture, in 1958 at the Union Dime Savings Bank. By 1959, he had been given his first commission for a wall piece, by the Ciba Geigy Corporation. His first outdoor sculpture commission, *From Yellow to White to Blue to Black*, was for the Xerox Building in El Segundo, California (1967–70). He then executed a number of public works in polychromed metal. A retrospective of his work opened in 1969 at the Kunsthalle Basel and traveled to Leverkusen, Berlin, and Amsterdam. In 1981, the Joslyn Art Museum, Omaha, organized a major retrospective. Sugarman now lives and works in New York.

First represented in a Whitney Museum Annual in 1960, Sugarman has since been in five Annuals and Biennials as well as five other group exhibitions. The Museum owns one Sugarman sculpture, *Criss Cross* (1965), acquired in 1977 as part of the Lawrence H. Bloedel Bequest.

Fig. 76. George Sugarman, *Six Forms in Pine*, 1959. Laminated pine, 59 x 143 x 59″ (149.9 x 363.2 x 149.9 cm). Collection of the artist; courtesy Robert Miller Gallery, New York.

Day, Holliday T., Irving H. Sandler, and Brad Davis. *Shape of Space: The Sculpture of George Sugarman* (exhibition catalogue). Omaha, Nebraska: Joslyn Art Museum in association with the Arts Publisher, New York, 1981.

Frank, Elizabeth. "Multiple Disjunctions." *Art in America*, 71 (September 1983), pp. 144–49.

Goldin, Amy. "The Sculpture of George Sugarman." *Arts Magazine*, 40 (June 1966), pp. 28–31.

———, and Peter F. Althaus. *George Sugarman* (exhibition catalogue). Basel: Kunsthalle Basel, 1969.

Sandler, Irving H. "Sugarman Makes a Sculpture." *Art News*, 65 (May 1966), pp. 34–37.

———. *Concrete Expressionism* (exhibition catalogue). New York: Loeb Student Center, New York University, 1965.

Chronology

1945–46

Within four years of the opening of Peggy Guggenheim's Art of This Century Gallery (1942), New York's first important showcase for the new New York art, three other progressive galleries are established. The Kootz Gallery (1945) shows the work of David Hare, Ibram Lassaw, and Herbert Ferber throughout the fifties, as well as that of several major New York School painters. The Charles Egan Gallery (1946) represents, among others, Reuben Nakian, Isamu Noguchi, and Raoul Hague. The Betty Parsons Gallery (1946) takes on many artists who had shown at Art of This Century, including Jackson Pollock, Mark Rothko, and Clyfford Still; Seymour Lipton shows there from 1948 to 1961, and Ferber in 1947, 1950, and 1953. The emergence of these galleries indicates a shift in patronage from government art programs to a newly receptive private market.

1946

Robert Coates, writing in *The New Yorker*, applies the term "Abstract Expressionism" to the new New York painting for the first time.

A major Henry Moore exhibition is held at The Museum of Modern Art, surveying work in which interior spaces are articulated by the volumes that surround them.

"14 Americans," the second of a series of group shows organized by Dorothy C. Miller, opens at The Museum of Modern Art. This series, begun in 1942, is the museum's first systematic commitment to living American artists. "14 Americans" includes several Abstract Expressionist artists, including Hare, Noguchi, Theodore Roszak, Robert Motherwell, and Arshile Gorky.

1947

Pollock begins his all-over "drip" paintings.

The Tiger's Eye, devoted to the contemporary arts, begins publication (through 1949). The following year it publishes "The Ides of Art: 14 Sculptors Write," in which Alexander Calder, Ferber, Hare, Lippold, Lipton, Noguchi, David Smith, and seven other sculptors each summarize the philosophical bases of their work. Along with *Possibilities* (1947–48), *The Tiger's Eye* promotes discussion among artists in several disciplines from both sides of the Atlantic.

1948–49

Subjects of the Artist, a studio program and influential Friday-evening lecture series at 35 East Eighth Street, is founded in the fall by William Baziotes, Motherwell, Rothko, and Hare. In the spring of 1949, its premises are taken over and renamed Studio 35 by Tony Smith and two other New York University art teachers. Both programs are important early forums for the exchange of ideas—and for socializing—among the Abstract Expressionist artists. In late 1949, some among the same group of artists rent 39 East Eighth Street, forming the Club, which also presents Friday-evening lectures and introduces a series of Wednesday-evening round tables. At these lectures and discussions, the New York painters and sculptors begin to articulate the terms of their artistic enterprise, and to converse with leading figures in the humanities, including anthropologist Joseph Campbell, philosopher Hannah Arendt, and literary critic Lionel Abel, all of whom are early speakers. Sculpture, and the relationship of art to architecture, are frequent lecture and panel topics. (The Club lasted until 1962.)

The Museum of Modern Art presents exhibitions of Naum Gabo, Antoine Pevsner, and Elie Nadelman, thus giving exposure to Gabo and Pevsner's pure Constructivist forms and Nadelman's sophisticated vernacular figuration.

Louise Bourgeois exhibits a series of totemic figures at the Peridot Gallery (1949), arranging the seventeen allusively figurative sculptures in relationships that imply a social environment. This expressive integration of the entire gallery space prefigures the installation work which will engage many sculptors in the following decade.

1950

The Metropolitan Museum of Art announces an open competition for a contemporary American painting exhibition. The museum's express refusal to purchase work from this exhibition, and its defense of an exclusively figurative American painting collection, incites a group of eighteen painters, meeting in May at the Club, to publicly protest and to boycott the competition. The "Irascible 18," as they are dubbed after their open letter is published on the front page of *The New York Times*, are supported by ten sculptors, including Ferber, Lassaw, Lipton, Roszak, Hare, Bourgeois, and David Smith. The boycott is resumed when the Metropolitan announces a sculpture competition the following year, and Ferber, Lipton, and Roszak all reject invitations to become jurors—an honor which carries automatic acceptance of one work each. Smith, although he signed the open letter in 1950 and later wrote another urging continuation of the boycott, accepts; in addition, Roszak ultimately enters the competition and is included in the exhibition. Except for Smith, the jurors for the 1951 "American Sculpture—A National Competitive Exhibition" are all sculptors in the monolithic, figurative mode, or supporters of that tradition.

1951

Robert Beverly Hale writes in the catalogue of the Metropolitan's "American Sculpture" exhibition that only a small group of sculptors seems to be working in a non-objective style. Among the abstract sculpture which is included in the exhibition is work by Lee Amino, Calder, José de Rivera, Roy Gussow, Roszak, and George Rickey.

"Abstract Painting and Sculpture in America," a major exhibition of eighty artists' work, is curated by Andrew Carnduff Ritchie at The Museum of Modern Art, in part as a belated response to the 1936 "Cubism and Abstract Art" exhibition there, which with few exceptions included only European artists. Eleven sculptors are included, among them Richard Lippold, Roszak, Calder, David Smith, Lassaw, Ferber, Lipton, and Noguchi.

"Sculpture by Painters," at the Peridot Gallery, includes work by James Brooks, Jackson Pollock, Weldon Kees, and Gabor Peterdi; it indicates this generation of artists' interest in questioning traditional boundaries between the two media.

While trying to convert his yard into a garden, Richard Stankiewicz "excavates" a number of rusty metal objects, which he uses in the first of his welded "junk" sculptures, shown two years later at the Hansa Gallery.

Sixty-one Abstract Expressionist painters and sculptors, most of whom are charter members of the Club, rent a storefront at 60 East Ninth Street (with the help of Leo Castelli) to exhibit their work in the "Ninth Street Show."

A symposium at The Museum of Modern Art on the "Relationship of Painting and Sculpture to Architecture," in which professionals from both fields participate, explores an area of growing interest to the Abstract Expressionist sculptors.

1952

Harold Rosenberg uses the term "Action Painters" for the first time in *Art News*.

Painter Robert Rauschenberg, musicians John Cage and David Tudor, and choreographer

Merce Cunningham collaborate on an "Untitled Event" at Black Mountain College, North Carolina. This improvisational, interdisciplinary performance presages an era of mixed media events. It also signals a reaction to the insistent individuality of Abstract Expressionism.

In "The New Sculpture: A Symposium" at The Museum of Modern Art, David Smith, Roszak, Ferber, and Lippold discuss the revival of sculpture since World War II.

1953

The "Stable Show," a sequel to the 1951 "Ninth Street Show," is presented at Eleanor Ward's new Stable Gallery in the first of what become Stable Annuals (through 1957). In these Annuals (and also in one-artist exhibitions of New York painters and sculptors), the gallery reviews the work of the major Abstract Expressionists and their growing number of followers.

1954

Jacques Lipchitz has a retrospective at The Museum of Modern Art which draws attention to the influence his stocky totemic abstractions have exerted.

Ferber makes his first roofed sculpture and begins to experiment with the concept of environmental sculpture. *Roofed Sculpture with S-Curve* is begun; it is a small version of what was to become the room-sized 1961 Whitney Museum installation, *Sculpture to Create an Environment*. This installation, enveloping the viewer literally as well as figuratively, extends Ferber's ongoing experiments with manipulating perceptions of spatial scale and definition.

1955

A Brancusi retrospective opens at The Museum of Modern Art, and a Giacometti retrospective at The Solomon R. Guggenheim Museum; the organic abstractions of the former, and the Surrealist figuration of the latter, have a significant impact on the New York sculptors.

John I. H. Baur curates "The New Decade: 35 American Painters and Sculptors" at the Whitney Museum of American Art to show the achievement of postwar artists and to suggest the pre-eminence of American painters and sculptors. Of the stylistically diverse artists shown, eight are sculptors, among them Ferber, Hare, Lassaw, Lippold, and Lipton. Simultaneously, The Museum of Modern Art presents "The New Decade: 22 European Painters and Sculptors," an exhibition largely of non-objective or heavily

abstracted work. In the introduction to the catalogue, Andrew Carnduff Ritchie writes that "In art the Communists have sought to steal the term 'realism,'" which he says is also tainted by association with fascism. Both the statement and the exhibition demonstrate a profound shift in the status of abstract art, which before the war was popularly believed to be politically suspect.

1956
The Museum of Modern Art surveys the figurative, largely Surrealist sculpture of Julio Gonzalez, the first artist of the century to have created open, welded iron sculpture.

1957
David Smith has a major one-artist show at The Museum of Modern Art.

John Chamberlain, while visiting Larry Rivers in Easthampton, Long Island, gathers parts of a 1929 Ford found in Rivers' backyard into his first scrap auto metal sculpture, *Shortstop*, shown in 1958 at the Hansa Gallery.

1958
Mark di Suvero begins to use weathered wood, held together with bolts, chain, and rope, after discovering a supply of timber in a downtown lumber factory; the work that follows is exhibited in 1960 at the Green Gallery.

"Nature in Abstraction," an exhibition on the "Relation of Abstract Painting and Sculpture to Nature in Twentieth-Century American Art" curated by John I. H. Baur at the Whitney Museum, includes work by Bourgeois, Calder, Ferber, Hare, Lassaw, Lipton, Louise Nevelson, Noguchi, and David Smith, as well as contemporary New York School painters.

Nevelson creates *Moon Garden + One*, the first of her environments, with integrated, theatrical groupings of sculptural elements. Her use of full-scale sculpted walls in this installation is a breakthrough in the development of environmental work, with which Bourgeois and Ferber are also involved.

Alfred H. Barr, Jr., Thomas B. Hess, and Harold Rosenberg participate in a panel at the Club called "Has the Situation Changed?" in which the now-established position of Abstract Expressionism is evaluated.

It Is, a magazine edited by sculptor Phillip Pavia that closely follows the ideas exchanged at the Club, commences publication.

1959
The Museum of Modern Art's "Recent Sculpture U.S.A.," presenting work by Calder, Chamberlain, Gabriel Kohn, Lipton, Nakian, David Smith, and Stankiewicz, opens in New York and tours nationally through 1960.

1960
Frank Lloyd Wright's new building for The Solomon R. Guggenheim Museum opens. Its radically sculptural helical configuration creates an architectural emblem of modern art.

Jean Tinguely's self-destroying sculpture, *Hommage à New York*, is exhibited at The Museum of Modern Art. The deliberate irreverence of this assemblage, indebted though it is to Stankiewicz and Chamberlain, seems deliberately opposed to the earnest, principled aesthetic of the Abstract Expressionist sculptors.

1965

In February and March, two "Waldorf Panels on Sculpture" are held under the auspices of *It Is* magazine, which publishes the transcripts in its autumn issue. The panels are named after a cafeteria where many of the participants frequently met to exchange ideas prior to the establishment of the Club. Sculptor Phillip Pavia, the editor of *It Is*, moderates. He begins by suggesting that spontaneity and design are opposing concerns for contemporary sculptors, and discussion follows on the possibility of immediacy in sculpture. The panelists address such familiar issues as the abiding influence of European Surrealism, the defining characteristics of an American sensibility, and the relationships between Abstract Expressionist painters and sculptors. Ethical questions are raised about appropriating found objects or exploiting chance effects. The roles of the subconscious, of science, and of religion in sculptural production—all longstanding issues—are reviewed. However, the panelists also consider the younger artists' introduction of Pop imagery, Happenings, and audience participatory sculpture. Pollock is frequently mentioned, and Andy Warhol's name arises, too. The panels implicitly acknowledge the need for a summation of sculptural concepts soon to be popularly superseded. (Participants include Ferber, Lassaw, Noguchi, Claes Oldenburg, George Segal, and Sugarman.)

Selected Bibliography

American Sculpture 1951: A National Competitive Exhibition (exhibition catalogue). New York: The Metropolitan Museum of Art, 1951.

Andersen, Wayne. "The Fifties." *Artforum*, 5 (Summer 1967), pp. 60–67.

————. *American Sculpture in Process: 1930/1970*. Boston: New York Graphic Society, 1975.

Ashton, Dore. *Modern American Sculpture*. New York: Harry N. Abrams, 1967.

————. *The New York School: A Cultural Reckoning*. New York: Penguin Books, 1980.

Baur, John I. H. *The New Decade: 35 American Painters and Sculptors* (exhibition catalogue). New York: The Macmillan Company in cooperation with the Whitney Museum of American Art, 1955.

————. *Nature in Abstraction: The Relation of Abstract Painting and Sculpture to Nature in Twentieth-Century American Art* (exhibition catalogue). New York: Whitney Museum of American Art, 1958.

Brummé, C. Ludwig. *Contemporary American Sculpture*. Foreword by William Zorach. New York: Crown Publishers, 1948.

Burnham, Jack. *Beyond Modern Sculpture: The Effects of Science and Technology on the Sculpture of This Century*. New York: George Braziller, 1968.

"Contemporary Sculptors." *Art in America*, 44 (Winter 1956–57), pp. 9–33. Articles by James Johnson Sweeney on Alexander Calder; Andrew Carnduff Ritchie on Seymour Lipton; Robert Goldwater on David Hare; H. H. Arnason on Theodore Roszak; Addison Franklin Page on Isamu Noguchi; Richard Lippold on "How to Make a Sculpture"; Clement Greenberg on David Smith.

Craven, Wayne. *Sculpture in America*. New York: Thomas Y. Crowell, 1968.

Geldzahler, Henry. *New York Painting and Sculpture 1940–1970* (exhibition catalogue). Essays by Harold Rosenberg, Robert Rosenblum, Clement Greenberg, William Rubin, and Michael Fried. New York: E. ·P. Dutton in association with The Metropolitan Museum of Art, 1969.

Giedion-Welcker, Carola. *Contemporary Sculpture: An Evolution in Volume and Space*. New York: George Wittenborn, 1955.

Goldwater, Robert. "Reflections on the New York School." *Quadrum*, 8 (1960), pp. 17–36.

————. *What Is Modern Sculpture?* New York: The Museum of Modern Art, and Greenwich, Connecticut: New York Graphic Society, 1969.

Goossen, Eugene C., Robert Goldwater, and Irving H. Sandler. *Three American Sculptors: Ferber, Hare, Lassaw*. New York: Grove Press, 1959.

Greenberg, Clement. "The Present Prospects of American Painting and Sculpture." *Horizon*, no. 93–94 (October 1947), pp. 20–30.

————. "The New Sculpture." *Partisan Review*, 16 (June 1949), pp. 636–42.

———. "Sculpture in Our Time." *Arts,* 32 (June 1958), pp. 22–25.

———. "America Takes the Lead: 1945–64." *Art in America,* 53 (August-September 1965), pp. 108–29.

———. "Recentness of Sculpture." *Art International,* 11 (April 20, 1967), pp. 19–21.

Guilbaut, Serge. *How New York Stole the Idea of Modern Art: Abstract Expressionism, Freedom, and the Cold War.* Chicago: The University of Chicago Press, 1983.

Hess, Thomas B. "Great Expectations." *Art News,* 55 (Summer 1956), pp. 36–38, 59–62.

———. "U.S. Sculpture: Some Recent Directions." *Portfolio,* including *Art News Annual,* no. 1 (1959), pp. 112–27, 146, 148, 150–52.

Hultén, K. G. Pontus. *The Machine as Seen at the End of the Mechanical Age* (exhibition catalogue). New York: The Museum of Modern Art, 1968.

Hunter, Sam. *Modern American Painting and Sculpture.* New York: Dell, 1959.

"The Ides of Art: 14 Sculptors Write." Articles by artists, including Alexander Calder, Herbert Ferber, David Hare, Richard Lippold, Seymour Lipton, Isamu Noguchi, and David Smith. *The Tiger's Eye,* 4 (June 1948), pp. 73–106.

Kootz Gallery. *The Muralist and the Modern Architect* (exhibition catalogue). Statements by artists, including David Hare and Frederick Kiesler. New York: 1950.

Krauss, Rosalind E. *Passages in Modern Sculpture.* New York: The Viking Press, 1981.

———. "Magician's Game: Decades of Transformation, 1930–1950." In *200 Years of American Sculpture* (exhibition catalogue). New York: David R. Godine in association with the Whitney Museum of American Art, 1976.

Marter, Joan M., Roberta K. Tarbell, and Jeffrey Wechsler. *Vanguard American Sculpture 1913–1939* (exhibition catalogue). New Brunswick, New Jersey: Rutgers University Art Gallery, 1979.

Miller, Dorothy C., ed. *14 Americans* (exhibition catalogue). Statements by artists, including David Hare, Isamu Noguchi, and Theodore Roszak. New York: The Museum of Modern Art, 1946.

———, ed. *15 Americans* (exhibition catalogue). Statements by artists, including Frederick Kiesler, Herbert Ferber, and Richard Lippold. New York: The Museum of Modern Art, 1952.

———, ed. *12 Americans* (exhibition catalogue). Statements by and about artists, including Raoul Hague, Ibram Lassaw, and Seymour Lipton. New York: The Museum of Modern Art, 1956.

———, ed. *16 Americans* (exhibition catalogue). Statements by artists, including Louise Nevelson and Richard Stankiewicz. New York: The Museum of Modern Art, 1959.

———, ed. *Americans 1963* (exhibition catalogue). Statements by and about artists, including Lee Bontecou, Gabriel Kohn, and Michael Lekakis. New York: The Museum of Modern Art, 1963.

Motherwell, Robert, and Ad Reinhardt, eds. *Modern Artists in America*. Including "Artists' Sessions at Studio 35," edited by Robert Goodnough; "The Western Round Table of Modern Art," edited by Douglas MacAgy; and "Paris–New York 1951," by Michel Seuphor. New York: Wittenborn Schultz, 1951.

Munro, Eleanor. "Explorations in Form: A View of Some Recent American Sculpture." *Perspectives U.S.A.*, 16 (Summer 1956), pp. 160–72.

The Museum of Modern Art. "The New Sculpture: A Symposium" (panel typescript). Speakers: David Smith, Theodore Roszak, Herbert Ferber, and Richard Lippold. Moderator: Andrew Carnduff Ritchie. New York: 1952.

Plous, Phyllis. *19 Sculptors of the 40s* (exhibition catalogue). Introduction by David Gebhard. Santa Barbara, California: The Art Galleries, University of California at Santa Barbara, 1973.

———. *7 + 5: Sculptors in the 1950s* (exhibition catalogue). Santa Barbara, California: The Art Galleries, University of California at Santa Barbara, 1976.

Read, Herbert. *A Concise History of Modern Sculpture*. New York: Praeger Publishers, 1964.

Ritchie, Andrew Carnduff. *Abstract Painting and Sculpture in America*. New York: The Museum of Modern Art, 1951.

———. *Sculpture of the Twentieth Century*. New York: The Museum of Modern Art, 1952.

Rose, Barbara. "Looking at American Sculpture." *Artforum*, 3 (February 1965), pp. 29–36.

Rosenblum, Robert. "The New Decade." *Arts Digest*, 29 (May 15, 1955), pp. 20–23.

Sandler, Irving H. "American Construction Sculpture." *Evergreen Review*, 2 (Spring 1959), pp. 136–46.

———. "The Club." *Artforum*, 4 (September 1965), pp. 27–31.

———. *Concrete Expressionism* (exhibition catalogue). New York: New York University Art Collection, Loeb Student Center, New York University, 1965.

———. *The New York School: The Painters and Sculptors of the Fifties*. New York: Harper & Row, 1978.

Saunders, Wade. "Touch and Eye: '50s Sculpture." *Art in America*, 70 (December 1982), pp. 90–105.

"A Season for Sculpture," *Arts*, 30 (January 1956), pp. 18–23.

Seitz, William C. *The Art of Assemblage*. New York: The Museum of Modern Art, 1961.

———, ed. "Contemporary Sculpture (articles by Sidney Geist, Robert Goldwater, Don Judd)." *Arts Yearbook 8*. New York: The Art Digest, 1965.

Selz, Jean. *Modern Sculpture: Origins and Evolution*. Translated by Annette Michelson. New York: George Braziller, 1963.

Seuphor, Michel. *The Sculpture of This Century*. New York: George Braziller, 1960.

Seymour, Charles, Jr. *Tradition and Experiment in Modern Sculpture*. Washington, D.C.: The American University Press, 1949.

Soby, James Thrall. *Recent American Sculpture* (exhibition catalogue). New York: The Museum of Modern Art, 1959.

Steinberg, Leo. "Month in Review: 'Twelve Americans,' Part II." *Arts*, 30 (July 1956), pp. 25–28.

Trier, Eduard. *Form and Space: Sculpture of the 20th Century*. New York: Frederick A. Praeger, 1968.

Varnedoe, Kirk. "Abstract Expressionism." In *"Primitivism" in Twentieth-Century Art: The Affinity of the Tribal and the Modern*, edited by William Rubin, vol. II, pp. 615–60. New York: The Museum of Modern Art, distributed by New York Graphic Society Books, Little Brown and Company, Boston, 1984.

"Waldorf Panels 1 & 2 on Sculpture." *It Is*, 6 (Autumn 1965), pp. 77–80, 109–13.

Weiss, Jeffrey. "Science and Primitivism: A Fearful Symmetry in the Early New York School." *Arts Magazine*, 57 (March 1983), pp. 81–87.

Works in the Exhibition

The works listed below reflect the exhibition in New York only. Deletions and substitutions will be made for travel.

Dimensions are in inches followed by centimeters; height precedes width precedes depth. Where a base is indicated, dimensions are inclusive.

Peter Agostini

Clouds, 1959–60
Plaster, 16 x 11½ x 11½ (40.6 x 29.2 x 29.2)
Collection of the artist

Lee Bontecou

Untitled, 1960
Welded steel and canvas, 55 x 66½ x 20
(139.7 x 168.9 x 50.8)
Collection of Mrs. Albert List

Louise Bourgeois

Mortise, 1950
Painted wood, 54 x 17 x 16 (137.2 x 43.2 x 40.6)
Collection of the artist

One and Others, 1955
Painted wood, 18¼ x 20 x 16¾ (46.4 x 50.8 x 42.5)
Whitney Museum of American Art, New York; Purchase 56.43

Alexander Calder

Constellation, c. 1945
Wood and wire, 40 (101.6) wide
Collection of Mrs. Marcel Breuer

Bifurcated Tower, 1950
Painted metal and wire, 58 x 72 x 53
(147.3 x 182.9 x 134.6) irregular
Whitney Museum of American Art, New York; Gift of the Howard and Jean Lipman Foundation, Inc. (and exchange) 73.31

John Chamberlain

Cord, 1957
Steel, 17½ x 13 x 10 (44.5 x 33 x 25.4)
Collection of Allan Stone

Johnnybird, 1959
Enameled steel, 59 x 53 x 45½ (149.9 x 134.6 x 115.6)
Collection of Sydney and Frances Lewis

Mark di Suvero

Che Faro Senza Eurydice, 1959
Wood, rope, and nails, 84 x 104 x 91
(213.4 x 264.1 x 231.1)
Private collection

Herbert Ferber

Apocalyptic Rider, 1947
Bronze, 44½ x 35 x 25 (113 x 89 x 63.5)
Grey Art Gallery and Study Center, New York University Art Collection; Anonymous Gift

The Action Is the Pattern, 1949
Lead with brass rods, 18 (45.7) high
Collection of Kate and Christopher Rothko

The Flame, 1949
Brass, lead, and soft solder, 65½ x 26 x 20
(166.4 x 66 x 51)
Whitney Museum of American Art, New York; Purchase 51.30

Jackson Pollock, 1949
Lead, 17⅝ x 30 (44.8 x 76.2)
The Museum of Modern Art, New York; Purchase

Roofed Sculpture with S-Curve, 1954–59
Bronze, 50½ x 60 x 22 (128.3 x 152.4 x 55.9)
Collection of Edith Ferber

Sun Wheel, 1956
Brass, copper, and stainless steel, 56¼ x 29 x 19 (142.9 x 73.7 x 48.3)
Whitney Museum of American Art, New York; Purchase 56.18

Raoul Hague

Mount Marion Walnut, 1952–54
Walnut, 32½ x 36¾ x 26 (82.6 x 93.3 x 66)
Albright-Knox Art Gallery, Buffalo; Gift of Seymour H. Knox

David Hare

The Dinner Table, 1950
Welded steel, 90 x 62½ x 47½ (228.6 x 158.8 x 120.7)
Grey Art Gallery and Study Center, New York University Art Collection; Gift of John Goodwin

Figure Waiting in Cold, 1951
Bronze and iron, on stone base, 71⅞ x 10½ x 11 (182.6 x 26.7 x 27.9)
The Museum of Modern Art, New York; Given anonymously

Frederick Kiesler

Galaxy, 1951
Wood construction, 144 x 168 x 168
(365.8 x 426.7 x 426.7)
Collection of Mrs. Nelson A. Rockefeller

The Arch: A Sculpted Rainbow to Walk Through, 1959–65
Bronze and aluminum, 118 x 134 x 36
(229.7 x 340.4 x 91.4)
Collection of Lillian Kiesler

Gabriel Kohn

Guest in the House, 1958
Wood, 50 x 21 x 11½ (127 x 53.3 x 29.2)
Private collection

Square Root, 1958
Laminated and doweled wood, 28 x 40 x
14¾ (71.1 x 101.6 x 37.5)
Whitney Museum of American Art, New
York; Purchase 60.20

Ibram Lassaw

Uranogeod, 1946
Stainless steel and cast alloy, 11 x 17 x 8
(27.9 x 43.2 x 20.3)
Collection of the artist

Milky Way/Polymorphic Space, 1950
Plaster, 52 x 26 x 24 (132.1 x 66 x 61)
Collection of the artist

Kwannon, 1952
Welded bronze with silver, 72 x 43 x 27
(182.9 x 109.2 x 68.6)
The Museum of Modern Art, New York;
Katherine Cornell Fund

Antipodes, 1960
Various alloys, 21 x 16 x 11½ (53.3 x 40.6 x
29.2)
Collection of Ernestine Lassaw

Tathata, 1960
Various alloys, 15 x 16 x 15½ (38.1 x 40.6 x
39.4)
Collection of the artist

Michael Lekakis

Keraia, 1958
Cherry, with yellow pine base, 83 x 55 x 35
(210.8 x 139.7 x 88.9)
Philadelphia Museum of Art; Gift of
Clorinda and Joseph Margolis

Aiora, 1958
Black pine, 20 x 71 x 18 (50.8 x 180.3 x
45.7) width
Collection of the artist

Elm on Elm on Elm, 1958–84
Elm, 83 x 30 x 32 (210.8 x 76.2 x 81.3)
Collection of the artist

Sympan, 1960
Oak, 86 x 28 x 26 (218.4 x 71.1 x 66)
Whitney Museum of American Art, New
York; Gift of the Friends of the Whitney
Museum of American Art (and purchase)
61.33

Richard Lippold

Primordial Figure, 1947–48
Brass and copper wire, 96 x 24 x 18 (243.8 x
61 x 45.7)
Whitney Museum of American Art, New
York; Gift of the Friends of the Whitney
Museum of American Art, Charles Simon
(and purchase) 62.27

Seymour Lipton

Pavilion, 1948
Wood, copper, and lead, 24 x 14 x 25 (61 x
35.6 x 63.5)
Collection of the artist

Thunderbird, 1951–52
Bronze on steel, 27½ x 36½ x 16 (69.9 x
92.7 x 40.6)
Whitney Museum of American Art, New
York; Wildenstein Benefit Purchase Fund
53.18

Earth Forge II, 1955
Nickel-silver on steel, 31⅛ x 52⅝ x 19¼
(79.1 x 133.7 x 48.9)
The Brooklyn Museum; Dick S. Ramsay
Fund

Sea King, 1955
Nickel-silver on Monel metal, 29½ x 42½ x
20 (74.9 x 108 x 50.8)
Albright-Knox Art Gallery, Buffalo;
A. Conger Goodyear Fund

Pioneer, 1957
Nickel-silver on Monel metal, 94 x 32
(238.8 x 81.3)
The Metropolitan Museum of Art; Gift of
Mrs. Albert A. List

Sorcerer, 1957
Nickel-silver on Monel metal, 60¾ x 36 x
25 (154.3 x 91.4 x 63.5)
Whitney Museum of American Art, New
York; Gift of the Friends of the Whitney
Museum of American Art 58.25

Reuben Nakian

Olympia, 1961
Bronze, 72 x 74 x 27 (182.9 x 188 x 68.6)
Whitney Museum of American Art, New
York; Gift of the Friends of the Whitney
Museum of American Art (and purchase)
63.48

Louise Nevelson

Black Majesty, 1955
Wood, 27⅞ x 9½ x 32 (70.8 x 24.1 x 81.3)
Whitney Museum of American Art, New
York; Gift of Mr. and Mrs. Ben Mildwoff
through the Federation of Modern Painters
and Sculptors, Inc. 56.11

Tender Being, 1956
Wood, 72 x 35 x 3 (182.9 x 88.9 x 7.6)
Evansville Museum of Arts and Science,
Evansville, Indiana

Isamu Noguchi

Kouros, 1944–45
Pink Georgia marble, on slate base, 117
(297.2) high
The Metropolitan Museum of Art, New
York; Fletcher Fund

Hanging Man, 1945
Aluminum, 60 x 6 x 7 (152.4 x 15.2 x 17.8)
Collection of the artist

Insects in Rice Field, 1947
Bamboo dowels, masking tape, and glue,
42 x 10 x 5 (106.7 x 25.4 x 12.7)
The Pace Gallery, New York

Theodore Roszak

Spectre of Kitty Hawk, 1946–47
Welded and hammered steel brazed with
bronze and brass, 40¼ (102.2) high; base
18 x 15 (45.7 x 38.1)
The Museum of Modern Art, New York;
Purchase

Night Flight, 1958
Steel, 96 x 120 x 58 (244.8 x 304.8 x 147.3)
including base
Collection of Mrs. T. Roszak

David Smith

Helmholtzian Landscape, 1946
Painted iron, on wooden base, 18⅜ x 19 x
7⅜ (46.7 x 48.3 x 19.7)
Collection of Mr. and Mrs. David Lloyd
Kreeger

Royal Bird, 1947–48
Steel, bronze, and stainless steel, 21¾ x
59 x 9 (55.2 x 149.9 x 22.9) including base
Walker Art Center, Minneapolis; Gift of
the T. B. Walker Foundation

The Cathedral, 1950
Painted steel, 34⅛ x 24½ x 17⅛ (86.7 x
64.8 x 43.6)
Private collection

Star Cage, 1950
Painted welded metals, 44⅞ x 51¼ x 25¾
(114 x 130.2 x 65.4) including base
University Art Museum, University of
Minnesota, Minneapolis; John Rood
Sculpture Collection

The Hero, 1952
Painted steel, 73¹¹⁄₁₆ x 25½ x 11¾ (187.2 x
64.8 x 29.8)
The Brooklyn Museum; Dick S. Ramsay
Fund

Tanktotem IV, 1953
Steel, 92⅝ x 29 x 34 (235.3 x 73.7 x 86.4)
Albright-Knox Art Gallery, Buffalo; Gift of
Seymour H. Knox

Richard Stankiewicz

Kabuki Dancer, 1956
Cast iron and steel, on wooden base, 84 x
25 x 26 (213.4 x 63.5 x 66)
Whitney Museum of American Art, New
York; Gift of the Friends of the Whitney
Museum of American Art 57.12

Untitled, 1960
Steel, 37 x 35¼ x 31¾ (94 x 89.5 x 80.6)
Collection of Maurice Vanderwoude

George Sugarman

Six Forms in Pine, 1959
Laminated pine, 59 x 143 x 59 (149.9 x
363.2 x 149.9)
Collection of the artist; courtesy Robert
Miller Gallery, New York

Yellow Top, 1960
Laminated wood, polychromed, 87½ x 54 x
34 (222.3 x 137.2 x 86.4)
Walker Art Center, Minneapolis; Gift of
the T. B. Walker Foundation

Photograph Credits

Photographs of the works of art reproduced
have been supplied, in the majority of cases,
by the owners or custodians of the works, as
cited in the captions. The following list
applies to photographs for which an addi-
tional acknowledgment is due:
Oliver Baker: Fig. 26
Scott Bowron: Fig. 63
Rudolph Burckhardt: Figs. 27, 41, 56, 60
Geoffrey Clements: Figs. 8, 23, 25, 46, 51,
55, 59, 61, 68, 70, 71, 72, 75
Ken Cohen: Fig. 45
Charles H. Coles: Fig. 21
Edith Ferber: Figs. 37, 38
Herbert Ferber: Figs. 9, 18
Allan Finkelman: Fig. 57
Gottscho/Schleisner: Fig. 36
Helga Photo Studio: Fig. 3
Joslyn Art Museum, Omaha: Fig. 76
Kate Keller: Fig. 1
M. Knoedler & Co., Inc., New York: Fig. 44
Robert E. Mates: Fig. 2
Herbert Matter: Fig. 64
James Matthew: Fig. 14
Dennis McWaters: Fig. 53
Ed Meneely: Fig. 52
O.E. Nelson: Fig. 39
Soichi Sunami: Figs. 30, 35, 73
John Tennant: Fig. 48
Jerry L. Thompson: Figs. 11, 42, 43, 44,
49, 50
The Towne Studio: Fig. 24
De Witt Ward: Fig. 5
Alan Zindman: Fig. 65

This publication was organized at the
Whitney Museum of American Art by
Doris Palca, Head, Publications and
Sales; Sheila Schwartz, Editor; Elaine
Koss, Associate Editor; and Emily Sussek,
Secretary.

Designer: Michael Glass Design, Inc.
Typesetter: Michael and Winifred Bixler
Printer: Eastern Press, Inc.